Lives of
Giovanni Bellini

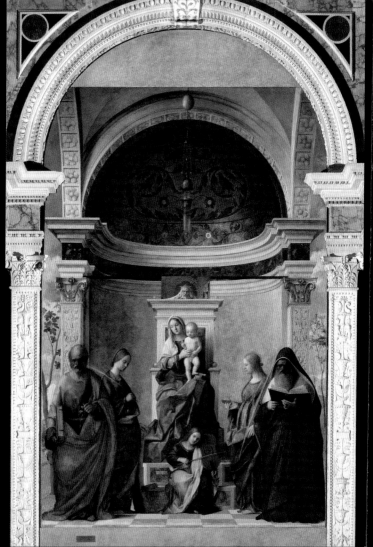

Lives of
Giovanni Bellini

Giorgio Vasari

Carlo Ridolfi

Marco Boschini

Isabella d'Este

translated by
Frank Dabell

edited and introduced by
Davide Gasparotto

The J. Paul Getty Museum, Los Angeles

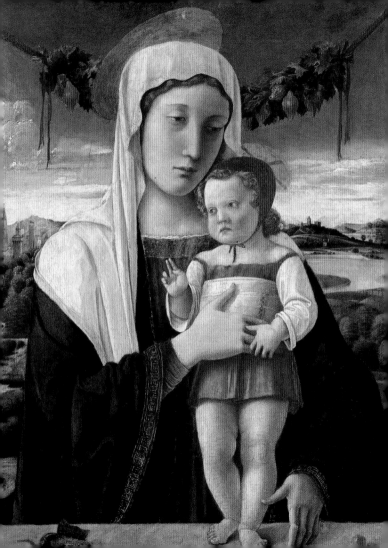

CONTENTS

Opposite: Virgin and Child (Lehman Madonna), c. 1465-70

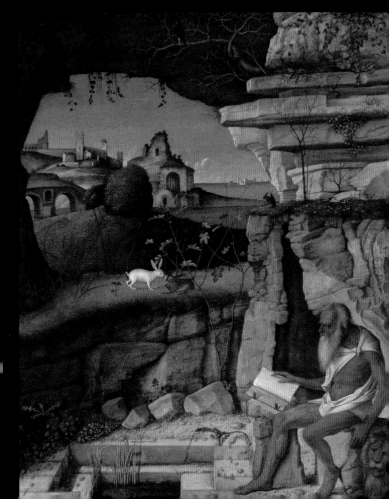

INTRODUCTION

DAVIDE GASPAROTTO

On November 29, 1516, the Venetian patrician Marin Sanudo noted the death of Giovanni Bellini (c. 1435–1516) in his diary, observing how his fame was "known throughout the world" and that notwithstanding his advanced age, he was still painting "outstandingly". Nine years earlier, in February 1507, when Giovanni's brother, Gentile, had died, Sanudo had written: "There remains his brother Giovanni Bellini, who is the most excellent painter in Italy". For the thirty-five-year-old Albrecht Dürer, visiting Venice in 1506, Giovanni Bellini had appeared very aged yet still "the best painter of all". At the opening of the sixteenth century, Giovanni was absolutely unrivalled in his dominant position: he was the official painter of the Republic of Venice, ran the main artistic workshop in the city, and could count the most prestigious names among his clients, even beyond the borders of the Most Serene Republic.

Bellini was the recognized master of all genres of painting practiced in Venice during the second half

Opposite: St Jerome, 1505

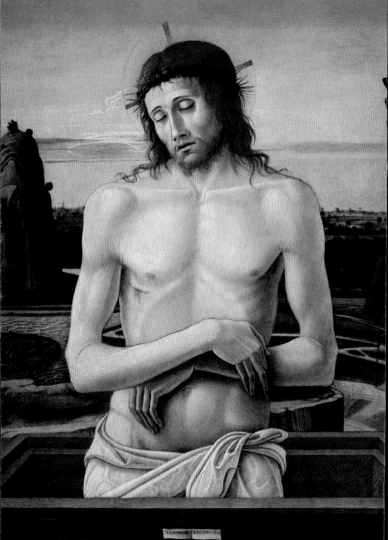

IOANNES BONONVS

of the fifteenth century: pictures destined for private devotion, narrative cycles, altarpieces, and portraits. Towards the end of his career these traditional categories were augmented with secular allegories and mythological paintings. His role in defining and bringing these genres to maturity was fundamental. His pictures of the Virgin and Child, repeated through infinite variation, the half-length Sacred Conversations, the images of the suffering Christ, and the small panels with representations of St Jerome in a landscape completely transformed and renewed domestic devotional painting. In the realm of altarpieces, Bellini was the protagonist of a shift from the multipanelled Gothic polyptych to the unified Renaissance *pala*; his specific contribution was the creation of the Sacred Conversation, a type of painting placed above an altar in which the Virgin, seated on a throne, often within expansive ecclesiastical architecture, is depicted in silent conversation with a group of saints. Even if they are fewer in number, his portraits – which introduce the sitter in three-quarter profile as in Flemish paintings, which enjoyed enormous popularity in Italy at that time – reflect a marked turning

Opposite: Imago Pietatis, c. 1457

Overleaf: Sacred Conversation - Virgin and Child with four saints and a donor, 1507

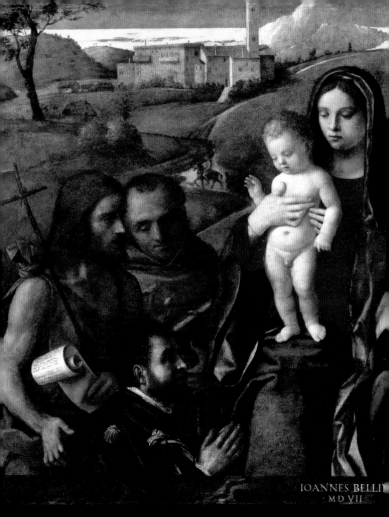

IOANNES BELLI
· M D VII ·

point in the success of the individual portrait in Venice. Our sense of his contribution to the history of narrative painting is more limited because of the irreparable loss of the decorative cycles in the Doge's Palace in the great fire of 1577. But documents convey Bellini's continual commitment, almost always alongside his brother, Gentile, to the execution of monumental narrative canvases – both for the different confraternities and for the residence of the doge – which have played such a large part in defining our image of Venetian Renaissance painting.

Perhaps only Raphael can equal Bellini in the history of Italian painting for his extraordinary ability to assimilate the styles of other artists, both within Venice and beyond: the rarefied spirituality of Byzantine icons; the lesson of his father, Jacopo; the intense dialogue with the refined *all'antica* style of his brother-in-law, Andrea Mantegna, and the harsh, expressive sculpture of Donatello in Padua; an attention to the smallest of details and an interest in the description of nature by the Flemish masters, whose work could be admired in so many Venetian homes; the admirable synthesis of perspective and colour in the paintings by Piero della Francesca and Antonello da Messina; and finally, toward the end of his long career, even the subtle atmospheric qualities of Giorgione, young enough to have been his grandson. Bellini combined constant research into expressive innovation

with equally remarkable technical experimentation, playing a leading role in the shift from egg tempera, the very tradition of Italian painting, to oil, inspired by the Flemish model. The move was a gradual one, and occasionally Bellini used both binders on the same painting, allowing him to achieve effects of luminosity and transparency that were absolutely unprecedented.

Early sources agree that Giovanni and Gentile Bellini were pupils of their father, Jacopo, the most important and innovative Venetian painter of the first half of the fifteenth century. According to Giorgio Vasari, Giovanni died in 1516 at the age of ninety, so he would have been born in 1426, and therefore the older of the brothers; this is contradicted, however, by several contemporary sources that indicate Gentile was older. Moreover, since Jacopo's wife, Anna Rinversi, does not mention Giovanni in her will of 1471, it has often been suggested that he was the illegitimate son of Jacopo, born out of wedlock. Giovanni's date of birth thus remains a matter of debate, with a variety of hypotheses that range from the traditional 1426 to the end of the 1430s. A different birthdate implies a completely different reconstruction of the first years of his career; some scholars see him already emerging during the 1450s, while others maintain that his independent career only started at the beginning of the 1460s. In any case, it is important to remember

two dates: 1459, when Giovanni is documented as living in his own house in the parish of San Lio in Venice, and 1460, when – according to some sixteenth-century sources – together with his father, Jacopo, and brother, Gentile, he signs an altarpiece in the Gattamelata chapel in the basilica of Sant'Antonio in Padua. (The work was subsequently lost, though some scholars have proposed that parts of it can be identified with fragments now housed in various museums.)

Giovanni's first important independent commission was the St Vincent Ferrer polyptych of the mid-1460s (Venice, Santi Giovanni e Paolo), but it was starting in the 1470s that he must have been truly regarded as the city's most important painter, dividing his time between the execution of monumental altarpieces and small, exquisite paintings destined for private devotion. Initial and highly significant recognition came in 1479, when his brother, Gentile, left for Constantinople, and Giovanni took his place restoring and renewing the paintings in the Doge's Palace. His activity received the blessing of the state when he was appointed official painter of the Serenissima on February 26, 1483, which brought with it the privileges of the *senseria* (a tax-exempt broker's license) at the Fondaco dei Tedeschi and

Opposite: St Vincent Ferrer polyptych, c. 1465

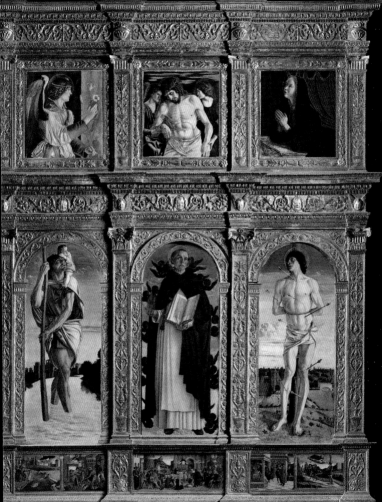

exemption from his obligations to the *Fraglia*, the painters' guild.

It was certainly in the 1470s that the literati became aware of Giovanni Bellini: in about 1474-75 the Veronese humanist Felice Feliciano already considered him "the most celebrated painter in the world", while for Raffaele Zovenzoni, a poet from Trieste, Giovanni was "the most distinguished painter". These are the years in which the artist completed one of his most important works, the altarpiece for the high altar of San Francesco in Pesaro. After this great endeavour his career was well and truly launched, and in comparing the works of the two brothers, more perceptive contemporary observers recognized the undeniable superiority of Giovanni, who was acknowledged from the 1490s not only as the principal painter in Venice but also as one of the greatest living artists in Italy. In the main, literary praise was quite generic, but toward the end of the fifteenth century one also begins to find mentions of specific works: in 1494, for example, the Brescian humanist Bernardino Gadolo recorded the *Resurrection*, painted for the church of San Michele in Isola and now in the Gemäldegalerie, Berlin, as a "most beautiful panel" (ill. p. 77). Marcantonio Sabellico's *De situ urbis Venetae* (1492) and Marin Sanudo's

Opposite: Pesaro altarpiece (principal section), c. 1472-75

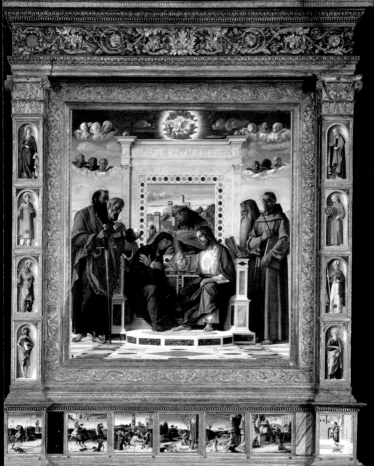

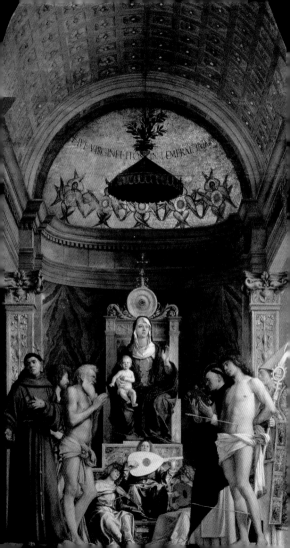

De origine, situ et magistratibus urbis Venetae (1493) both mention the San Giobbe altarpiece of about 1480, one of Giovanni's major masterpieces. The lost cycle in the Doge's Palace, for which Sabellico had probably provided the inscriptions, received a large number of literary references, both in prose and poetry.

The end of the 1490s and opening years of the new century saw the famous correspondence with the marchioness of Mantua, Isabella d'Este. By this point, Bellini was profoundly conscious of his primacy, allowing himself to deny requests from even the most important patrons. Thus when Isabella asked him to execute a painting for her famous *camerino* (also known as the *studiolo,* or little study), diplomatic stalling was followed by definitive refusal. In declining this commission, Bellini doubtless wished to avoid being compared with his brother-in-law, Andrea Mantegna, in an area in which Mantegna excelled and toward which Bellini had no particular inclination: *all'antica* allegorical painting. He countered Isabella's request with an offer to paint a Nativity comprising a "work with the infant Christ and Saint John the Baptist and something in the background with other fantasies" – in other words, a sort of Sacred Conversation set in a landscape, a genre in which

Opposite: San Giobbe altarpiece, c. 1480

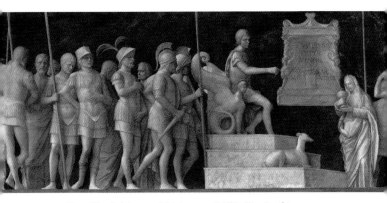

Above: The Continence of Scipio, c. 1506. This all'antica *frieze was commissioned from Bellini as a companion piece to a painting by Mantegna, who had died before being able to carry it out himself*

he was unrivalled. Some scholars have sought to identify this painting, which was delivered in 1504, as the mysterious *Sacred Allegory* in the Uffizi Gallery, a picture that stands alone within Bellini's œuvre and might well have been a fitting work for such a demanding and refined patron.

When some time later the marchioness attempted once more to persuade Bellini, through the good offices of the great poet Pietro Bembo, to paint a picture for her *studiolo*, the painter again turned her down, this time

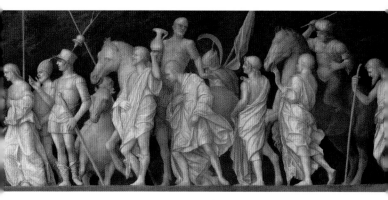

Overleaf: Sacred Allegory, c. 1500-1504

making an even stronger statement of intolerance with respect to the programme Isabella had asked Bembo to formulate. As Bembo wrote to Isabella on January 11, 1506, "the invention, which you tell me I am to find for his drawing, must be adapted to the fantasy of the painter. He does not like to be given many written details which cramp his style; his way of working, as he says, is always to wander at will in his pictures, so that they can give satisfaction to himself as well as to the beholder." Later, at the end of his career, Bellini would yield to

the persistent duke of Ferrara, Alfonso d'Este, creating his secular masterpiece *The Feast of the Gods* (1514), its landscape – as is well known – later reworked by Titian (Washington, National Gallery of Art; ill. p. 99).

After Bellini's death in 1516, the Venetian aristocrat and art connoisseur Marcantonio Michiel wrote a record of many of the painter's works that could be admired in both public places – principally churches – and private residences in Venice. Michiel provided the first reference to one of the artist's absolute masterpieces, *St Francis in the Desert* (New York, Frick Collection, ill. p. 28), a painting that was then in the house of Taddeo Contarini, praising especially the "nearby landscape, highly finished and admirably composed". Michiel himself was very likely the fortunate owner of one of the artist's late masterpieces, the so-called *Donà delle Rose Pietà* now in the Accademia in Venice.

Giorgio Vasari could not have known the invaluable notes made by Michiel, which remained in manuscript form until the beginning of the nineteenth century, but he could have met the cultivated Venetian during one of his sojourns in Venice, which provided him with important information for the biographies he was compiling. It was in the 1540s that Vasari (1511-1574), a painter and architect from Arezzo in Tuscany, had started his ambitious project of writing biographies of the major

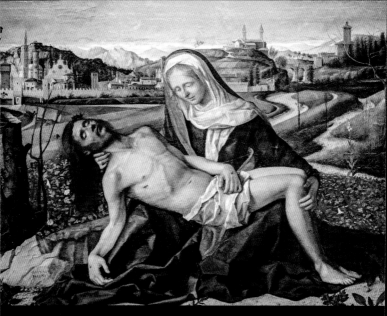

Donà delle Rose Pietà, c. 1495-1500

painters, sculptors, and architects from Cimabue to his contemporaries. In 1550 he published the *Lives*, dedicated to the duke of Florence, Cosimo I de' Medici, and again a largely revised and augmented edition in 1568. He travelled extensively in Italy in order to collect information and directly inspect works of art. He was in Venice twice, first in 1541 and again in 1566.

His *Vita di Iacopo, Giovanni e Gentile Bellini Pittori Veniziani*, published in the first compilation in 1550 (and then again in 1568 with additions and corrections) is the first complete biography of the three greatest Venetian artists of the Quattrocento. The account is dominated by the description of the large canvases of the Hall of the Great Council in the Doge's Palace, Bellini's most important public work, and to this day the text remains one of the most important sources for reconstructing this highly significant pictorial cycle, which was entirely lost during the great fire of 1577. But the Aretine painter and historian mentions many other works by Bellini, including some great altarpieces: one formerly on the altar of St Catherine in the church of Santi Giovanni e Paolo, also sadly destroyed by fire in 1867, as well as the Pala di Pesaro (c. 1473–75) mentioned above, the San Giobbe (c. 1480) and San Zaccaria (1505) altarpieces, and the polyptych in the church of the Frari (1488). Moreover, Vasari did not fail to record the most famous portrait by Bellini,

that of Doge Leonardo Loredan (London, National Gallery, ill. p. 36). The biography closes by quoting a famous sonnet by Bembo in praise of the portrait of a woman the poet loved – probably Maria Savorgnan – painted by Bellini (*"O immagine mia, celeste e pura"* – "O my image, celestial and pure"), and with the acclaim accorded to Bellini in the famous lines about painters in the 1532 edition of Ludovico Ariosto's *Orlando Furioso*, in which the great Venetian painter is listed alongside his brother-in-law, Mantegna, and the younger artists Leonardo, Michelangelo, Raphael, Sebastiano del Piombo, Titian, and Dosso and Battista Dossi.

Ariosto's praise notwithstanding, Vasari believed Bellini's works were closely tied to an era he must have felt was now irrevocably out of date. Vasari's reservations are clear, not so much in his account of the lives of the Bellinis, but in the opening to his biography of Pordenone, where he defined Giovanni's way of painting as "somewhat crude, hard and dry". These are the same reservations expressed by Ludovico Dolce in his *Dialogo di pittura, intitolato l'Aretino* (1557); though he judges Bellini to have been a "good and diligent master for his time", Dolce has Pietro Aretino draw a comparison between the grand manner of Titian, especially in the *Assumption of the Virgin* in the Frari, and the "dead, cold things by Giovanni Bellini".

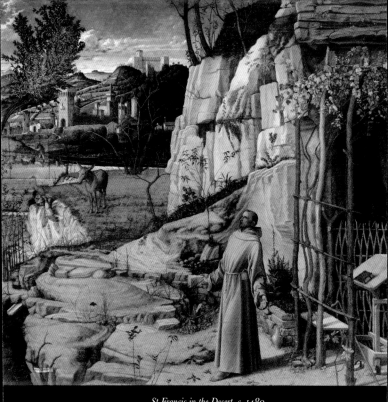

St Francis in the Desert, c. 1480

In 1660 the Venetian painter, restorer, engraver and art dealer Marco Boschini (1605-1681) published his *La Carta del navegar pitoresco*, whose title can be translated as "The map of pictorial navigation", a poem in the form of an imaginary dialogue between a dilettante Venetian senator and a professor of painting. The poem is an ardent patriotic and polemical defense of Venetian painting written in Venetian dialect and directed against the Roman and Tuscan norms represented by Vasari. Boschini is not interested in biographical details and he looks at paintings more with an artist's eye for formal problems and expressive qualities. His characterization of Bellini's style and his descriptions of the San Giobbe altarpiece and *St Francis in the Desert* are infused with intense poetic mood. In this way he is able to capture better than any of Bellini's biographers the profound spiritual tone of the artist's masterpieces, the subtle harmony of his colouring, and the glorious beauty of his landscapes.

A century after Vasari, Carlo Ridolfi (1594-1658) provided a new biography of Bellini. Ridolfi, a painter of rather modest ambition, did not did not possess Boschini's critical intelligence; rather, he was a compiler, diligently synthesizing the information given by Vasari. With the help of texts such as Francesco Sansovino's *Venetia città nobilissima et singolare* of 1581, and with his knowledge

of Venetian private collections, Ridolfi was in a position to expand the number of works in Bellini's œuvre, providing further information on their patrons and whereabouts. Ridolfi mentions several works not cited in Vasari – both in private hands, such as the *Contarini Madonna* (Venice, Accademia, ill. p. 73) and *Morelli Madonna* (Bergamo, Accademia Carrara, ill. p. 91), and on public view, including the *Paliotto Barbarigo* (Murano, San Pietro Martire, ill. overleaf), the *Baptism of Christ* (Vicenza, Santa Corona), and *Sts Jerome, Christopher and Louis of Toulouse* (Venice, San Giovanni Crisostomo), one of the masterpieces of Bellini's old age. Ridolfi is also the only author to record a portrait of the poet Pietro Bembo, which has been tentatively identified as the extraordinary *Portrait of a Young Man* (c. 1505) in the British Royal Collection (ill. p. 96).

Subsequent scholars and writers continued to recognize Giovanni Bellini as the patriarch of the Venetian school of painting but considered him above all the teacher of Giorgione, the true originator of modern painting in Venice. During the seventeenth and eighteenth centuries, the great champion of Venetian art was

Opposite: Sts Jerome, Christopher and Louis of Toulouse, 1513

Overleaf: The Paliotto Barbarigo: Virgin and Child with Sts Mark and Augustine, and Doge Agostino Barbarigo, 1488

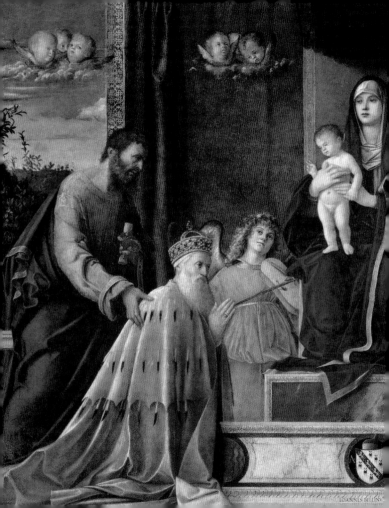

IOANNES BELLINVS

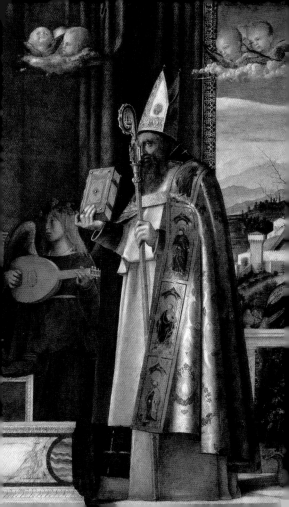

Titian, with Bellini appearing merely as a timid precursor. It was only beginning in the nineteenth century, with the gradual rediscovery of the "primitives", or the painters active before Raphael, that the qualities of Bellini's work – his minute attention to detail, sincerity of religious sentiment, and magnificent passages of landscape – once again attracted the attention of critics and the appreciation of collectors. Thus it came to be that John Ruskin, the most influential art critic of Victorian Britain, lauded the Frari polyptych (1488) and the San Zaccaria altarpiece (1505) as "the two best pictures in the world".

GIORGIO VASARI

*Jacopo, Giovanni, and Gentile Bellini
of Venice*

from

*Lives of the Most Excellent Painters,
Sculptors and Architects*

1568

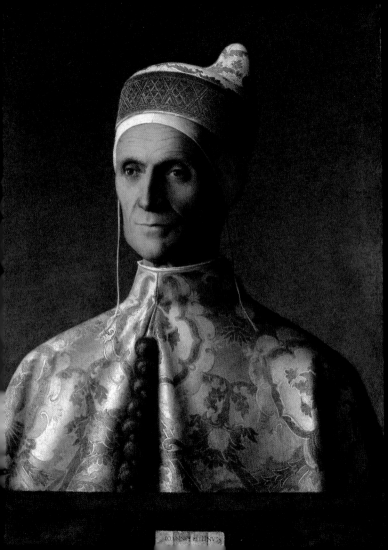

IOANNES BELLENVS

Enterprises that are founded on excellence, although their beginnings often appear humble and mean, keep climbing higher step by step, nor do they ever halt or take rest until they have reached the supreme heights of glory: as could be clearly seen from the poor and humble beginning of the house of the Bellini, and from the rank to which it afterwards rose by means of painting. Jacopo Bellini, a painter of Venice, having been a disciple of Gentile da Fabriano, worked in competition with that Domenico [Domenico Veneziano] who taught the method of colouring in oil to Andrea dal Castagno; but, although he laboured greatly to become excellent in that art, he did not acquire fame therein until after the departure of Domenico from Venice. Then, finding himself in that city without any competitor to equal him, he kept growing in credit and fame, and became so excellent that he was the greatest and most renowned man in his profession. And to the end that the name which he had acquired in painting might not only be maintained in his house and for his descendants, but might grow greater, there were born to him two sons of good and beautiful intelligence, strongly inclined to the art: one

Opposite: Doge Leonardo Loredan, 1501-1502

was Giovanni, and the other Gentile, to whom he gave that name in tender memory of Gentile da Fabriano, who had been his master and like a loving father to him. Now, when the said two sons had grown to a certain age, Jacopo himself with all diligence taught them the rudiments of drawing; but no long time passed before both one and the other surpassed his father by a great measure, whereat he rejoiced greatly, ever encouraging them and showing them that he desired them to do as the Tuscans did, who gloried among themselves in making efforts to outstrip each other, according as one after another took up the art: even so should Giovanni vanquish him, and Gentile should vanquish them both, and so on in succession.

The first works that brought fame to Jacopo were the portraits of Giorgio Cornaro[1] and of Caterina,[2] Queen of Cyprus; a panel which he sent to Verona, containing the Passion of Christ,[3] with many figures, among which he portrayed himself from the life; and a picture of the Story of the Cross, which is said to be in the Scuola of San Giovanni Evangelista.[4] All these works and many

(1) Lost, but probably by Gentile (2) *c.* 1500; by Gentile, Budapest, Museum of Fine Arts (3) In fact a fresco, destroyed 1750 (4) In fact a lost cycle of scenes of the life of Christ and the Virgin, 1465

others were painted by Jacopo with the aid of his sons; and the last-named picture was painted on canvas, as it has been almost always the custom to do in that city, where they rarely paint, as is done elsewhere, on panels of the wood of the tree that is called by many *poppio* and by some *gattice* [poplar]. This wood, which grows mostly beside rivers or other waters, is very soft, and admirable for painting on, for it holds very firmly when joined together with carpenters' glue. But in Venice they make no panels, and, if they do make a few, they use no other wood than that of the fir, of which that city has a great abundance by reason of the river Adige, which brings a very great quantity of it from Germany, not to mention that no small amount comes from Slavonia [now part of Croatia]. It is much the custom in Venice, then, to paint on canvas, either because it does not split and does not grow worm-eaten, or because it enables pictures to be made of any size that is desired, or because, as was said elsewhere, they can be sent easily and conveniently wherever they are wanted, with very little expense and labour. Be the reason what it may, Jacopo and Gentile, as was said above, made their first works on canvas.

To the last-named Story of the Cross Gentile afterwards added by himself seven other pictures, or rather, eight, in which he painted the miracle of the Cross of Christ, which the said *scuola* preserves as a

relic; which miracle was as follows. The said Cross
was thrown, I know not by what chance, from the
Ponte della Paglia into the canal, and, by reason of
the reverence that many bore to the piece of the Cross
of Christ that it contained, they threw themselves into
the water to recover it; but it was the will of God that
no one should be worthy to succeed in grasping it save
the prior of that *scuola*. Gentile, therefore, represent-
ing this story, drew in perspective, along the Grand
Canal, many houses, the Ponte della Paglia, the Piaz-
za of St Mark's, and a long procession of men and
women walking behind the clergy; also many who
have leapt into the water, others in the act of leaping,
many half immersed, and others in other very beauti-
ful actions and attitudes; and finally he painted the
said prior recovering the Cross.[5] Truly great were the
labour and diligence of Gentile in this work, consider-
ing the infinite number of people, the many portraits
from life, the diminution of the figures in the distance,
and particularly the portraits of almost all the men
who then belonged to that *scuola*, or rather, confra-
ternity. Last comes the picture of the replacing of the

(5) Three of the eight surviving paintings of the cycle are by Gen-
tile: *Procession in the Piazza of St Mark's* (1496), *Miracle at the Bridge of
San Lorenzo* (1500), and *Miraculous Healing of Pietro de' Ludovici* (1501).
Venice, Accademia

said Cross, wrought with many beautiful conceptions. All these scenes, painted on the aforesaid canvases, acquired a very great name for Gentile.

Afterwards, Jacopo withdrew to work entirely by himself, as did his two sons, each of them devoting himself to his own studies in the art. Of Jacopo I will make no further mention, seeing that his works were nothing out of the ordinary in comparison with those of his sons, and because he died not long after his sons withdrew themselves from him; and I judge it much better to speak at some length only of Giovanni and Gentile. I will not, indeed, forbear to say that although these brothers retired to live each by himself, nevertheless they had so much respect for each other, and both had such reverence for their father, that each, extolling the other, ever held himself inferior in merit; and thus they sought modestly to surpass one another no less in goodness and courtesy than in the excellence of their art.

The first works of Giovanni were some portraits from the life, which gave much satisfaction, and particularly that of Doge Loredan,[6] although some say that this was a portrait of Giovanni Mozzenigo, brother of that Piero who was doge many years before

(6) 1501-1502; London, National Gallery. Ill. p. 36

Loredan. Giovanni then painted a panel for the altar
of Santa Caterina da Siena in the church of San Gio-
vanni, in which picture, a rather large one, he painted
Our Lady seated, with the Child in her arms, and St
Dominic, St Jerome, St Catherine, St Ursula, and two
other Virgins; and at the feet of the Madonna he
made three boys standing, who are singing from a
book, a very beautiful group.[7] Above this he made the
inner part of a vault in a building, which is very beau-
tiful. This work was one of the best that had been
made in Venice up to that time. For the altar of San
Giobbe in the church of that saint, the same man
painted a panel with good design and most beau-
tiful colouring,[8] in the middle of which he made the
Madonna with the Child in her arms, seated on a
throne slightly raised from the ground, with nude
figures of St Job and St Sebastian, beside whom are
St Dominic, St Francis, St John, and St Augustine;
and below are three boys, sounding instruments with
much grace. This picture was not only praised then,
when it was seen as new, but it has likewise been
extolled ever afterwards as a very beautiful work.

(7) Lost in a fire, 1867. Known by an engraving of 1858 (8) c. 1480;
Venice, Accademia. Ill. p. 18, details opposite and pp. 102, 105, and 106

Opposite: Sts Francis, John and Job — detail of San Giobbe altarpiece, c. 1480

Certain noblemen, moved by the great praises won by these works, began to suggest that it would be a fine thing, in view of the presence of such rare masters, to have the Hall of the Great Council adorned with stories, in which there should be depicted the glories and the magnificence of their marvellous city, her great deeds, her exploits in war, her enterprises, and other things of that kind, worthy to be perpetuated by painting. In the memory of those who should come after, to the end that there might be added, to the profit and pleasure drawn from the reading of history, entertainment both for the eye and for the intellect, from seeing the images of so many illustrious lords wrought by the most skillful hands, and the glorious works of so many noblemen right worthy of eternal memory and fame. And so Giovanni and Gentile, who kept on making progress from day to day, received the commission for this work by order of those who governed the city, who commanded them to make a beginning as soon as possible. But it must be remarked that Antonio Viniziano had made a beginning long before with the painting of the same Hall, as was said in his *Life*, and had already finished a large scene, when he was forced by the envy of certain malignant spirits to depart and to leave that most honourable enterprise without carrying it on further.

Now Gentile, either because he had more experience and greater skill in painting on canvas than in fresco, or for some other reason, whatever it may have been, contrived without difficulty to obtain leave to execute that work not in fresco but on canvas.[9] And thus, setting to work, in the first scene he made the Pope presenting a wax candle to the Doge, that he might bear it in the solemn processions which were to take place; in which picture Gentile painted the whole exterior of St Mark's, and made the said Pope standing in his pontifical robes, with many prelates behind him, and the Doge likewise standing, accompanied by many senators. In another part he represented the Emperor Barbarossa; first, when he is receiving the Venetian envoys in friendly fashion, and then, when he is preparing for war, in great disdain; in which scene are very beautiful perspectives, with innumerable portraits from the life, executed with very good grace and amid a vast number of figures. In the following scene he painted the Pope exhorting the Doge and the Signori of Venice to equip thirty galleys at their common expense, to go out to battle against Frederick Barbarossa. This Pope is seated in his rochet [a kind of surplice] on the pontifical chair, with the

(9) All these works destroyed in a fire that gutted the Hall in 1577

Doge beside him and many senators at his feet. In this part, also, Gentile painted the Piazza and the façade of St Mark's, and the sea, but in another manner, with so great a multitude of men that it is truly a marvel. Then in another part the same Pope, standing in his pontifical robes, is giving his benediction to the Doge, who appears to be setting out for the fray, armed, and with many soldiers at his back; behind the Doge are seen innumerable noblemen in a long procession, and in the same part are the Palace and St Mark's, drawn in perspective.

This is one of the best works that there are to be seen by the hand of Gentile, although there appears to be more invention in that other which represents a naval battle, because it contains an infinite number of galleys fighting together and an incredible multitude of men, and because, in short, he showed clearly therein that he had no less knowledge of naval warfare than of his own art of painting. And indeed, all that Gentile executed in this work, the crowd of galleys engaged in battle; the soldiers fighting; the boats duly diminishing in perspective; the finely ordered combat; the soldiers furiously striving, defending, and striking; the wounded dying in various manners; the cleaving of the water by the galleys; the confusion of the waves; and all the kinds of naval armament; all

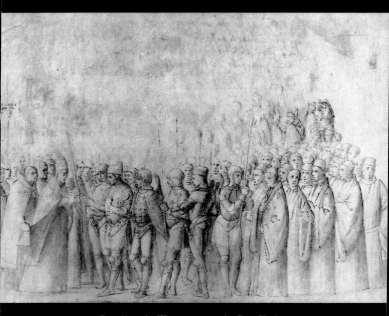

Pope Alexander III presents a sword to Doge Ziani:
Drawing originally attributed to Giovanni Bellini but probably
a copy after Gentile: one of only two to survive showing a
composition from the cycle in the Hall of the Great Council.
This drawing may have belonged to Rembrandt

this vast diversity of subjects, I say, cannot but serve to prove the great spirit, art, invention, and judgement of Gentile, each detail being most excellently wrought in itself, as well as the composition of the whole. In another scene he made the Doge returning with the victory so much desired, and the Pope receiving him with open arms, and giving him a ring of gold wherewith to espouse the sea, as his successors have done and still do every year, as a sign of the true and perpetual dominion that they deservedly hold over it. In this part there is Otto, son of Frederick Barbarossa, portrayed from the life, and kneeling before the Pope; and as behind the Doge there are many armed soldiers, so behind the Pope there are many cardinals and noblemen. In this scene only the poops of the galleys appear; and on the Admiral's galley is seated a Victory painted to look like gold, with a crown on her head and a sceptre in her hand.

The scenes that were to occupy the other parts of the Hall were entrusted to Giovanni, the brother of Gentile; but since the order of the stories that he painted there is connected with those executed in great part, but not finished, by Vivarino, it is necessary to say something of the latter. That part of the Hall which was not done by Gentile was given partly to Giovanni and partly to the said Vivarino, to the end that rivalry

might induce each man to do his best. Vivarino, then, putting his hand to the part that belonged to him, painted, beside the last scene of Gentile, the aforesaid Otto offering to the Pope and to the Venetians to go to conclude peace between them and his father Frederick; and, having obtained this, he is dismissed on oath and goes his way. In this first part, besides other things, which are all worthy of consideration, Vivarino painted an open temple in beautiful perspective, with steps and many figures. Before the Pope, who is seated and surrounded by many senators, is the said Otto on his knees, binding himself by an oath. Beside this scene, he painted the arrival of Otto before his father, who is receiving him gladly; with buildings wrought most beautifully in perspective, Barbarossa on his throne, and his son kneeling and taking his hand, accompanied by many Venetian noblemen, who are portrayed from the life so finely that it is clear that he imitated nature very well. Poor Vivarino would have completed the remainder of his part with great honour to himself, but, having died, as it pleased God, from exhaustion and through being of a weakly habit of body, he carried it no further, nay, even what he had done was not wholly finished, and it was necessary for Giovanni Bellini to retouch it in certain places.

Meanwhile, Giovanni had also made a beginning

with four scenes, which follow in due order those mentioned above. In the first he painted the said Pope in St Mark's, which church he portrayed exactly as it stood, presenting his foot to Frederick Barbarossa to kiss; but this first picture of Giovanni's, whatever may have been the reason, was rendered much more lifelike and incomparably better by the most excellent Titian. However, continuing his scenes, Giovanni made in the next the Pope saying mass in St Mark's, and afterwards, between the said Emperor and the Doge, granting plenary and perpetual indulgence to all who should visit the said church of St Mark's at certain times, particularly at that of the Ascension of Our Lord. There he depicted the interior of that church, with the said Pope in his pontifical robes at the head of the steps that issue from the choir, surrounded by many cardinals and noblemen, a vast group, which makes this a crowded, rich, and beautiful scene. In the one below this the Pope is seen in his rochet, presenting a canopy to the Doge, after having given another to the Emperor and keeping two for himself. In the last that Giovanni painted are seen Pope Alexander, the Emperor, and the Doge arriving in Rome, without the gates of which the Pope is presented by the clergy and by the people of Rome with eight standards of various colours and eight silver

trumpets, which he gives to the Doge, that he and his successors may have them for insignia. Here Giovanni painted Rome in somewhat distant perspective, a great number of horses, and an infinity of foot soldiers, with many banners and other signs of rejoicing on the castle of Sant' Angelo. And since these works of Giovanni, which are truly very beautiful, gave infinite satisfaction, arrangements were just being made to give him the commission to paint all the rest of that Hall, when, being now old, he died.

Up to the present we have spoken of nothing save the Hall, in order not to interrupt the sequence of the scenes; but now we must turn back a little and say that there are many other works to be seen by the hand of the same man. One is a panel which is now on the high altar of San Domenico in Pesaro.[10] In the church of San Zaccaria in Venice, in the chapel of San Girolamo, there is a panel of Our Lady and many saints,[11] executed with great diligence, with a building painted with much judgement; and in the same city, in the sacristy of the Friars Minor,[12] called the Ca' Grande,

(10) *Coronation of the Virgin*, 1472-75. Main section Pesaro, Museo Civico, ill. p. 17; upper section Rome, Pinacoteca Vaticana. In fact painted for San Francesco, Pesaro. (11) 1505, still in situ. Ill. frontispiece, detail pp. 84-85 (12) 1488; *Virgin and Child with Saints*, still in situ in Santa Maria Gloriosa dei Frari. Ill. overleaf

Virgin and Child with Nicolas of Bari, Peter, Mark and Benedict (Frari altarpiece), 1488

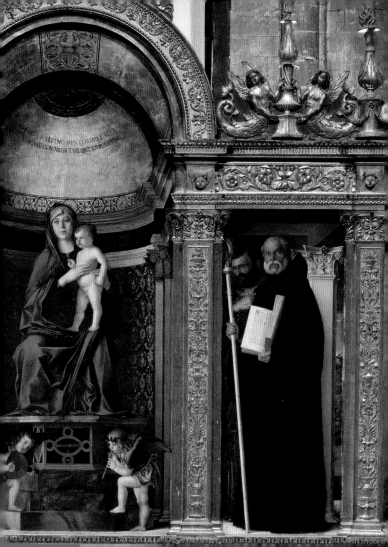

there is another by the same man's hand, wrought
with beautiful design and a good manner. There is
likewise one in San Michele di Murano,[13] a monastery
of Camaldolese monks; and in the old church of San
Francesco della Vigna, a seat of the Frati del Zoccolo,
there was a picture of a Dead Christ, so beautiful that
it was highly extolled before Louis XI, king of France,
whereupon he demanded it from its owners with great
insistence, so that they were forced, although very un-
willingly, to gratify his wish.[14] In its place there was put
another with the name of the same Giovanni, but not
so beautiful or so well executed as the first; and some
believe that this substitute was wrought for the most
part by Girolamo Mocetto, a pupil of Giovanni.[15] The
confraternity of San Girolamo also possesses a work
with little figures[16] by the same Bellini, which is much
extolled. And in the house of Messer Giorgio Cornaro
there is a picture, likewise very beautiful, containing
Christ, Cleophas, and Luke.[17]

In the aforesaid Hall he also painted, though not

(13) 1475-77; probably the *Resurrection*, Berlin, Gemäldegalerie.
Ill. p. 77 (14) Perhaps *Dead Christ in a Landscape, c.* 1510, Stockholm,
Nationalmuseum. Ill. opposite (15) Lost (16) Possibly refers to
two *Stories of St Jerome* by Lazzaro Bastiani, Venice, Accademia
(17) This *Supper at Emmaus* is lost

Opposite: Dead Christ in a Landscape, c. 1510

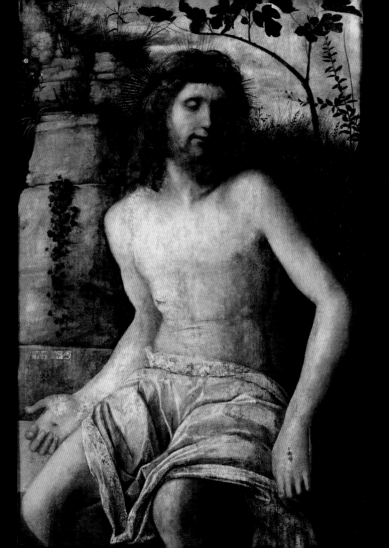

at the same time, a scene of the Venetians summoning forth from the monastery of the Carità a pope – I know not which – who, having fled to Venice, had secretly served for a long time as cook to the monks of that monastery; in which scene there are many portraits from the life, and other very beautiful figures. No long time after, certain portraits were taken to Turkey by an ambassador as presents for the Grand Turk, which caused such astonishment and marvel to that emperor, that, although pictures are forbidden among that people by the Muhammadan law, nevertheless he accepted them with great good-will, praising the art and the craftsman without ceasing; and what is more, he demanded that the master of the work should be sent to him. Whereupon the Senate, considering that Giovanni had reached an age when he could ill endure hardships, not to mention that they did not wish to deprive their own city of so great a man, particularly because he was then engaged on the aforesaid Hall of the Great Council, determined to send his brother Gentile, believing that he would do as well as Giovanni.

Therefore, having caused Gentile to make his preparations, they brought him safely in their own galleys to Constantinople, where, after being presented by the Commissioner of the Signoria to Mehmet,

he was received very willingly and treated with much favour as something new, above all after he had given that prince a most lovely picture,[18] which he greatly admired, being well-nigh unable to believe that a mortal man had within himself so much divinity, so to speak, as to be able to represent the objects of nature so vividly. Gentile had been there no long time when he portrayed the Emperor Mehmet from the life so well,[19] that it was held a miracle. That emperor, after having seen many specimens of his art, asked Gentile whether he had the courage to paint his own portrait; and Gentile, having answered "Yes," did not allow many days to pass before he had made his own portrait with a mirror, with such resemblance that it appeared alive.[20]

This he brought to the Sultan, who marvelled so greatly thereat, that he could not but think that he had some divine spirit within him; and if it had not been that the exercise of this art, as has been said, is forbidden by law among the Turks, that emperor would never have allowed Gentile to go. But either in fear of murmurings, or for some other reason, one day he summoned Gentile to his presence, and after

(18) Lost (19) London, National Gallery (20) Lost, though a self-portrait drawing survives, Berlin, Kupferstichkabinett

first causing him to be thanked for the courtesy that he had shown, and then praising him in marvellous fashion as a man of the greatest excellence, he bade Gentile demand whatever favour he wished, for it would be granted to him without fail. Gentile, like the modest and upright man that he was, asked for nothing save a letter of recommendation to the most Serene Senate and the most Illustrious Signoria of Venice, his native city. This was written in the warmest possible terms, and afterwards he was dismissed with honourable gifts and with the dignity of knight. Among other things given to him at parting by that sovereign, in addition to many privileges, there was placed round his neck a chain wrought in the Turkish manner, equal in weight to 250 gold crowns, which is still in the hands of his heirs in Venice.

Departing from Constantinople, Gentile returned after a most prosperous voyage to Venice, where he was received with gladness by his brother Giovanni and by almost the whole city, all men rejoicing at the honours paid to his talent by Mehmet. Afterwards, on going to make his reverence to the Doge and the Signoria, he was received very warmly, and commended for having given great satisfaction to that emperor according to their desire. And to the end that he might see in what great account they held the letters in which

that prince had recommended him, they decreed him a provision of 200 crowns a year, which was paid to him for the rest of his life. Gentile made but few works after his return; finally, having almost reached the age of eighty, and having executed the aforesaid works and many others, he passed to the other life, and was given honourable burial by his brother Giovanni in San Giovanni e Paolo, in the year 1501.*

Giovanni, thus bereft of Gentile, whom he had ever loved most tenderly, went on doing a little work, although he was old, to pass the time. And having devoted himself to making portraits from the life, he introduced into Venice the fashion that everyone of a certain rank should have his portrait painted either by him or by some other master; wherefore in all the houses of Venice there are many portraits, and in many gentlemen's houses one may see their fathers and grandfathers, up to the fourth generation, and in some of the more noble they go still farther back, a fashion which has ever been truly worthy of the greatest praise, and existed even among the ancients. Who does not feel infinite pleasure and contentment, to say nothing of the honour and adornment that they confer, at seeing the images of his ancestors, particularly if

* Gentile died on February 23, 1507

they have been famous and illustrious for their part in governing their republics, for noble deeds performed in peace or in war, or for learning or any other notable and distinguished talent? And to what other end, as has been said in another place, did the ancients set up images of their great men in public places, with honourable inscriptions, than to kindle in the minds of their successors a love of excellence and of glory?

For Messer Pietro Bembo, then, before he went to live with Pope Leo X, Giovanni made a portrait of the lady that he loved,[21] so lifelike that, even as Simone Sanese had been celebrated in the past by the Florentine Petrarch, so was Giovanni deservedly celebrated in his verses by this Venetian, as in the following sonnet:

O my image, celestial and pure*

where, at the beginning of the second quatrain, he says,

I believe that with her semblance my Bellini...

with what follows. And what greater reward can our craftsmen desire for their labours than that of being celebrated by the pens of illustrious poets, as that most

* Pietro Bembo, *Rime*, Sonnet xv. See p. 95
(21) Lost

Opposite: Portrait of a Young Man in Red, c. 1480

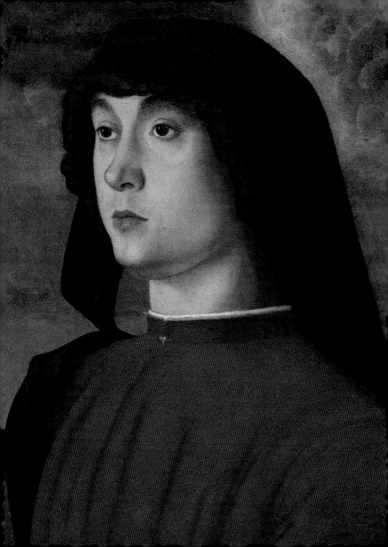

excellent Titian has been by the very learned Messer Giovanni della Casa, in that sonnet which begins –

> Thus Titian I see in a new shape

and in that other –

> They are hers, Cupid, the graceful blond tresses.*

Was not the same Bellini numbered among the best painters of his age by the most famous Ariosto, at the beginning of the thirty-third canto of the *Orlando Furioso*?

But to return to the works of Giovanni, that is, to his principal works, for it would take too long to try to make mention of all the pictures and portraits that are in the houses of gentlemen in Venice and in other parts of that country. In Rimini, for Signor Sigismondo Malatesta, he made a large picture containing a Pietà, supported by two little boys, which is now in San Francesco in that city.[22] And among other portraits he made one of Bartolommeo da Liviano, Captain of the Venetians.[23]

Giovanni had many disciples, for he was ever most

* Giovanni Della Casa, *Rime*, xxxiii and xxxiv. Both poems by Della Casa refer to a famous portrait of Elisabetta Querini by Titian.

(22) Rimini, Museo Civico, *c.* 1470-75. Ill. pp. 64-65 (23) Lost

willing to teach anyone. Among them, now sixty years ago, was Jacopo da Montagna, who imitated his manner closely, insofar as is shown by his works, which are to be seen in Padua and in Venice. But the man who imitated him most faithfully and did him the greatest honour was Rondinello da Ravenna, of whom Giovanni availed himself much in all his works. This master painted a panel in San Domenico at Ravenna,[24] and another in the Duomo, which is held a very beautiful example of that manner.[25] But the work that surpassed all his others was that which he made in the church of San Giovanni Battista, a seat of the Carmelite Friars, in the same city; in which picture, besides Our Lady, he made a very beautiful head in a figure of San Alberto, a friar of that Order, and the whole figure is much extolled.[26] A pupil of Giovanni's, also, although he gained but little thereby, was Benedetto Coda of Ferrara, who dwelt in Rimini, where he made many pictures, leaving behind him a son named Bartolommeo, who did the

(24) Either *Virgin and Child with Saints*, *c.* 1495, Ravenna, Accademia, or *Virgin and Child with Saints*, 1500-1510, Milan, Brera
(25) Lost (26) *c.* 1490-99; Niccolò Rondinelli, *Virgin and Child with St Albert and St Sebastian*, Ravenna, Accademia

Overleaf: Pietà, c. 1470-75

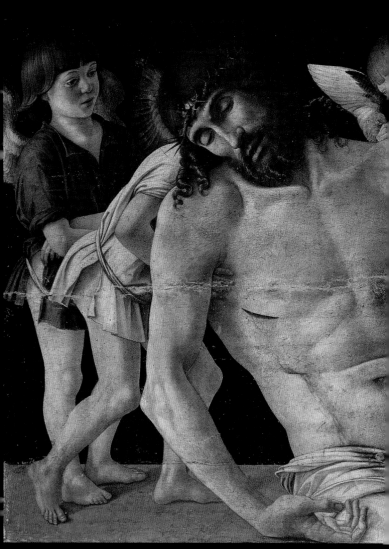

same. It is said that Giorgione da Castelfranco also pursued his first studies of art under Giovanni, and likewise many others, both from the territory of Treviso and from Lombardy, of whom there is no need to make record.

Finally, having lived ninety years, Giovanni passed from this life, overcome by old age, leaving an eternal memorial of his name in the works that he had made both in his native city of Venice and abroad; and he was honourably buried in the same church and in the same tomb in which he had laid his brother Gentile to rest. Nor were there wanting in Venice men who sought to honour him when dead with sonnets and epigrams, even as he, when alive, had honoured both himself and his country. About the same time that these Bellini were alive, or a little before, many pictures were painted in Venice by Giacomo Marzone, who, among other things, painted one in the chapel of the Assumption in Santa Lena,[27] namely, the Virgin with a palm, St Benedict, St Helen, and St John; but in the old manner, with the figures on tip-toe, as was the custom of those painters who lived in the time of Bartolommeo da Bergamo.

(27) 1441; Jacopo Moranzone, *Assumption of the Virgin with Saints*, Venice, Accademia

CARLO RIDOLFI

Life of Giovanni Bellini
Painter
Citizen of Venice

from

The Marvels of Art

1648

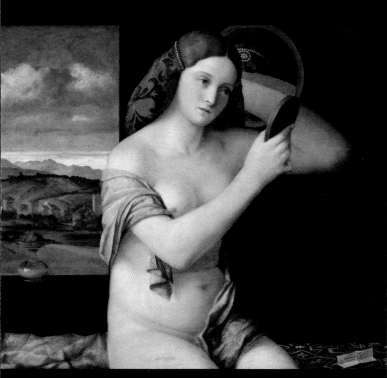

Young Woman with a Mirror, 1515

Giovanni, the brother of Gentile, was the recipient of the utmost divine grace, and went beyond all those who had painted up to his own day; and in his pictures one can see a compendium of the beautiful and elevated qualities Art had been able to produce until that time.

He developed the older style of painting, which tended to dryness, into something more exquisite and suave, with which he solely imitated nature, lending the images of saints a certain noble purity and devotion, and thus with good reason obtained the title of most celebrated among the painters of the past. We shall speak at length of this artist, and while his fame spreads far and wide, we shall preserve his memory in these pages.

Having moved away from his brother, Giovanni began to paint alone, though their souls were always related by love, each seeking with virtuous rivalry to enhance his talent, emulation being worthy of praise when it aims for a glorious end.

Now while Gentile sought with such an approach to open the path to fame, Giovanni was also proceeding towards glory through his generous artistry. But since his works are very numerous, as he painted not only for the public but for many private individuals,

it would be impossible to make full reference to each one, so we shall limit ourselves to a record of the best-known and famous ones.

Among the first things displayed in Venice were two panels, one with the Virgin, which he placed in San Giuliano,[1] but which was later removed, and the other with St Catherine in San Geminiano,[2] which was replaced by Tintoretto when the altar was refurbished.

In San Felice he made another one with Our Lady on the altar of the Cinturari, now placed by the side of that church in their *scuola*.[3] In competition with other painters he made two pictures of the life of St Jerome for the confraternity of that name. One shows the saint seated by the wall of his convent, preaching to his brothers, who are seated around him in simple postures. One of them leans feebly on a stick, another listens, and yet another hangs lengths of cloth out above a loggia. In the foreground Bellini painted very natural graves and grass.[4]

In the other the same saint can be seen in his study, placed on a stool as he reads, and there are brothers who study, while others speak to one another,

(1) Lost (2) Lost (3) Lost (4) Lost

and everything is expressed with great artistry and diligence; and he wrote his name and the year 1464.[5]

In the Magistracy of the Avogaria he represented Our Lord dead, supported by the Virgin Mother and by St John, above the sepulchre.[6] In 1472, in the refectory of the Fathers of the Carità, he made a chiaroscuro painting of the Crucified Christ with the Maries and Doctors of the Church.[7]

For the church of Santi Giovanni e Paolo he painted the grand panel of St Catherine of Siena, with the Virgin seated under a majestic portico supported by the most natural pillars, full of embellishment, with Sts Dominic, Jerome, Ursula, and other blessed figures. At the feet of the Virgin are three little angels holding a book, in the act of parting their lips as they sing.[8]

Having followed the custom of artists of the past by working in tempera, Bellini then learned to paint in oil, a method brought to Venice, as we said at the beginning, by Antonello da Messina, who had learned this in Flanders from John of Bruges [Jan van Eyck], and who in this manner had painted a panel in San

(5) Lost (6) *c.* 1465; Venice, Doge's Palace (7) Lost (8) Lost in a fire in 1867 but known through an engraving (1858)

Cassiano* with Our Lady seated, with St Michael, and another in San Giuliano,† which were later removed.

He also made for Queen Caterina Cornaro an image of the Virgin which she gave to one of her ladies-in-waiting, who married into the Avogadro family in Treviso, where the picture is still housed.[9] In the year 1490 he painted a fresco in San Nicolò in the same city, of two armed men *all'antica* flanking the tomb of a personage of the Onigo family.[10]

In Venice, also by his hand, is an effigy of Our Lady in the house of the Contarini,[11] and one of St Christopher in Ca' Zanne di Piazza.[12] Signor Giovanni van Veerle has sent to his home in Antwerp, with many other excellent pictures, a most devout image by our artist of the Virgin Mary accompanied by four saints.[13]

But returning to our earlier discourse: having seen that new manner of painting in which there appeared union and subtleness of colour that was not

* Some parts survive, Vienna, Kunsthistorisches Museum
† One panel, *St Sebastian*, survives in Dresden, Gemäldegalerie

(9) Lost (10) Now generally attributed to Giovanni Buonconsiglio
(11) *c.* 1475-80, Venice, Accademia, ill. opposite (12) Lost (13) Lost

Opposite: Contarini Madonna, c. 1475-80

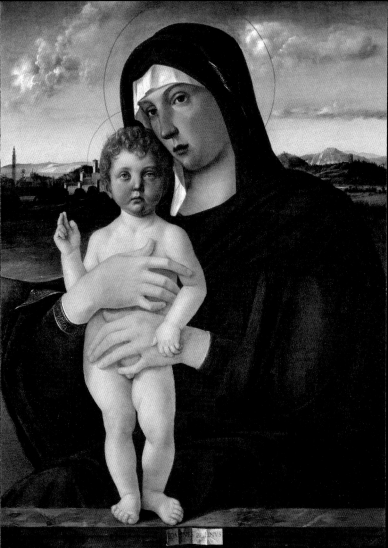

IOANNES BELLINVS

practiced in tempera, and not knowing how to imagine Antonello's way of painting, Giovanni introduced himself into his house as a gentleman, with the intention of having himself portrayed, and as he wore a Venetian toga he easily deceived him. Thus Antonello began to paint, with no concerns, and Giovanni, observing him every time he dipped his brush into the linseed oil, became aware of how he worked. Consequently, since Antonello brought such a beautiful invention to Venice, he was much appreciated by those Signori, and shortly thereafter died aged forty-nine, and was honoured with this inscription by the Venetian painters:

Antonio the Painter,
the chief ornament of his native Messina,
and of all Sicily,
is buried in this spot.
He is not only honoured with the lasting respect of his
profession on account of the singular skill and grace
which his pictures exhibit, but also because he was
the first who conferred splendour and durability
on Italian painting, by the immixture
of colours with oil.

In this way, then, Giovanni, having learned the way of tempering his colours with oil (though others say that Antonello first bestowed the secret on a

certain Master Domenico [i.e. Domenico Veneziano]),
also applied himself to this manner of painting, his
example being thereafter followed by all Italian
painters.

Giovanni painted for the Fathers of the Carità the
panel with the Saviour in the Jordan,[14] and for the
nuns of the Miracoli St Jerome in the baleful desert.[15]
In San Giobbe he represented on a great altar the Vir-
gin seated under a canopy upheld by the most natural
pilasters, so closely resembling the architectural orna-
ments beside them that they appear sculpted.[16] One
sees St Job, with his sores, St Francis, who gazes lov-
ingly at the Cross, a nude St Sebastian, and St Louis:
truly natural figures in which Giovanni sought to em-
body the piety required in such images of saints, not
concerning himself with foreshortening and attitudes
that were later practiced by subsequent painters; nor
can one fully describe the grace and beauty of the lit-
tle angels seated at the feet of the Virgin, playing the
viol, lute, and violin with such gentle airs and sweet
movements that they enrapture the soul; and those
types of figures prompt the highest devotion in the

(14) Lost but attributed in other sources to Cima da Conegliano
(15) *c.* 1480; perhaps the St Jerome, Florence, Uffizi (16) *c.* 1480;
Venice, Accademia. Ill. p. 18, details pp. 42, 102, 105 and 106

minds of the faithful. One may with good reason sub-
scribe to these words:

> They only lack speech – you'd seek no less from life;
> Nor is that lacking, if you believe your eyes.*

In San Giovanni dal Tempio he painted over the
high altar, most delicately, the Saviour in the Jordan,
and the patron knight and prior kneeling to one side
with the Cross on his chest, and views of Alpine hills.[17]
He carried out two other panels in San Michele,
the islet near Murano, one showing Our Lady with
the Child, and Sts Peter and Paul, and two saints of
the order in niches to the side, with the portrait of
Pietro Priuli, Procurator of Saint Mark's, the patron
of the altar;[18] the other in the chapel of Marin Gior-
gio, of the Resurrected Christ, with small figures of
armed guards by the Sepulchre, set under a hill, with
a distant view of a town with many mountains, trees
and animals, and the Maries on their way.[19]

* Tasso, *Jerusalem Delivered*, XVI.2

(17) 1505, with workshop assistance; still in situ (18) *c.* 1500-1505;
with workshop assistance; Düsseldorf, Kunstsammlungen der Stadt
(19) *c.* 1475-77; Berlin, Gemäldegalerie. Ill. opposite

Opposite: The Resurrection, c. 1475-77

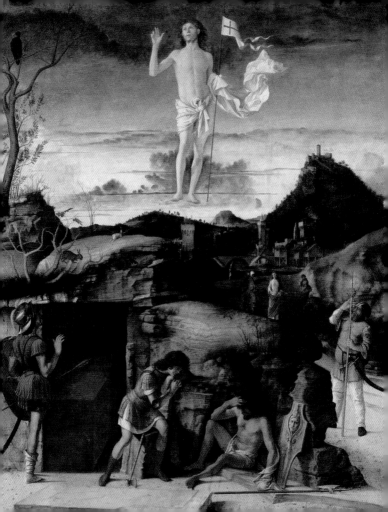

But let us speak of the paintings he did in the Hall of the Great Council, in competition with his brother, since Giovanni, having earned the gratitude of the citizens for his talents, was no less cherished and favoured than Gentile, and he was likewise commissioned to paint the main part of the remaining stories of Pope Alexander.[20]

In the first he showed Doge Sebastiano Ziani with the senators disembarking from the Bucintoro at the church of the Carità, recognising the Pontiff Alexander III who stood incognito among those fathers; and below one could read these lines to elucidate the stories:

The first night [the Pope] refused to stay with the canons of San Salvatore, who took him to the monastery of Santa Maria Caritatis and where he served in their habit.

The other, close by, read as follows:

By the grace of God a certain pilgrim in Venice for a vow, while visiting the aforementioned church of Santa Maria Caritatis recognised the Pope and informed the illustrious Don Sebastiano Ziani, who was then the most excellent doge of Venice, that it was the Pope who was in that church.

The third expressed the action depicted:

(20) Entire cycle destroyed in fire of December 20, 1577

The Doge, the noble Councillors and the whole of the citizenship of Venice, and similarly the Patriarch of Grado and the Bishop of Venice and the entire clergy with crosses approach the Pope, who is surprised by so large a crowd. The most devout Doge, on bended knee, kissed the most holy feet, and giving a cloak, mitre and foot ornaments, assured the Pope that he should resume his good spirits and papal adornments, as he now found himself in a most safe, free and powerful city.

Next, in another canvas, following the order of the said story, was narrated the naval battle that took place between the said Doge and Otto, son of the Emperor Frederick, in which Bellini depicted the interlocking of many galleys, arranging with variety and artifice the number of combatants, who boldly strike one another, some protecting themselves with shields from the arrows, and many others falling into the water, trying to grasp planks of wood, yet others who are dead, swept by the waves; and the Doge above, on the gilded poop, to whom the young Otto is brought as prisoner. One cannot express the effort, diligence and art used by Bellini in representing such diverse figures, such variety of weaponry, and such beauty of ornament, for which it is said he spent eleven years in completing this immense endeavour. Thereon one could read:

The Doge engaged in an atrocious battle and with diving help and the courage of the Venetians defeated the Imperial fleet, and captured Otto with sixty triremes, while the rest, with the exception of a few that had swiftly taken flight, were either burnt or sunk in the high seas.

Giovanni also finished a story which had been left incomplete by Vivarini, in which one could see Otto before his father, who, his indignation now calmed, obtained peace with the Pontiff; and this story, like the following ones, included many portraits of senators (confusingly described by Sansovino), of Andrea Donato, knight, dressed in gold brocade, of Jacopo Venier and of Jacopo Marcello, admirals; of Candiano Bollani and of Francesco Pasqualigo, both doctors [of law], and Pasqualigo proffering a book to the celebrated jurist Raucasio, and beside him Gentile Bellini; and this inscription:

The Emperor rejoiced to see his son, who [had shown] great courage in the face of what would horrify another, and authorised him to treat for peace.

In another scene the Pope, Emperor and Doge have disembarked in the port of Ancona, and the citizens having brought them ceremonial umbrellas, the Pope orders that another should immediately be brought for the Doge, commanding that it could also

be used by his successors; and here were also portrayed men of letters, Giovanni Aripoldo, Theodore of Gaza, Emanuel Chrysoloras, Demetrios Chalcocondyles and George Trapezuntinus, dressed in the Greek manner. The adjoining scene shows the said three princes met outside Rome with solemn magnificence by clergy and nobility and numerous knights robed in their rich finery, lavishly mounted on horseback, with standards of various colours before them, silver trumpets signifying jubilation, and a mass of people celebrating as they acclaim the arrival of the Pope. The painter included in this solemn scene Hermolao Barbaro, Angelo Poliziano, Girolamo Donato in golden robes, Antonio Cornaro, reader in philosophy, and his son Zaccheria wearing old-fashioned *cappucci* on their heads, with this inscription:

Then Pope Alexander, the Emperor and the Doge of Venice proceeded rapidly to Rome on horseback; and as they approached the leaders of the priesthood and all the clergy went out to meet them followed by the leading citizens and the entire nobility, after which the people animated by extreme enthusiam came with great joy and veneration to greet the arrivals.

The next story represented the Pope bestowing the standards and silver trumpets on the Doge, so that it

should be borne in his memory during the great solemnities, and for the victory achieved. In this scene there were also shown Paolo Barbo, knight, brother of Pope Paul II, Andrea Molino, Antonio Dandolo, doctor, Luca Zeno, and Domenico Marino, procurators of St Mark's, Nicolò Michele, knight, also a procurator of St Mark's, and one could read there:

> When Alexander entered the Romans presented [the Doge] with eight standards of various colours and as many silver trumpets, these being offered by the Pope with great solemnity as ornaments for his dignity to him and to all his successors.

Finally, and with much decorum, Giovanni represented the Pope, Pontiff and Emperor before the church of St John in Lateran, where two seats were readied, one for the Pope and the other for the Emperor, and the Pope commanding that another similar seat should be brought for the Doge, so that the honour would be equal. Here he portrayed Marcantonio Sabellico, the writer of Venetian history, Giorgio Amadeo, Giovanni Merula, and other illustrious figures of that time, as well as many of the common people crowded there before this marvellous spectacle, with the following words:

> Pope Alexander visited the Lateran Basilica with the

Emperor and the Venetian Doge. Here as it happened there was one seat for the Pontiff, and another for the Emperor Frederick, and the Pope ordered that a third should be given to the Venetian as a sign of his dignity, that the Venetian Doge should enjoy in perpetuity.

Four precious panels were painted by Giovanni in Venice, one in the sacristy of the Frari, with the figure of the Queen of Heaven, with the Child at her breast, as customary, seated under a golden canopy, and two little angels at her feet, who with a graceful manner play the lute and the flageolet, and in the shutters are Sts Nicholas and Benedict and two other saints.[21] The second is in San Zaccaria, and in that one is likewise depicted the Virgin with the Child in her arms, and on the sides Sts Peter, Mary Magdalene and Catherine with divine demeanours and traits, and St Jerome dressed as a cardinal, and with a little angel at their feet, playing a viol, and in the apse above such noble and naturally painted architecture that it seems truly present.[22] This painting is held to be among the most beautiful by this artist, who inscribed his name on it, and the year 1505. The third is in San Giovanni Crisostomo, and shows St Jerome

(21) 1488; still in situ in Santa Maria Gloriosa dei Frari. Ill. pp. 52-53
(22) 1505; still in situ. Ill. frontispiece, detail overleaf

San Zaccaria
altarpiece, 1505

at the summit of a rock, holding a book, St Christopher, St Louis, not only beautifully formed but with mellow colours.[23] The fourth is placed in the Chapel of the Conception in San Francesco della Vigna, likewise containing Our Lady, St Sebastian and a portrait.[24]

He also painted for the church of the Nuns of the Angeli at Murano another grand panel with the Assumption of the Virgin adorned with delightful drapery, and in the lower part, conversing in a circle, Sts Peter, Paul, Francis, Louis, Augustine, Anthony Abbot and the Baptist, truly one of his most delicate endeavours.[25] Above a grille window is a large picture portraying Doge Agostino Barbarigo kneeling in adoration before the Queen of Heaven, his protectors St Mark and St Augustine, and two angels who are playing two *lire da braccio* with truly celestial faces, and, in a smaller picture above another window, the Saviour laid to rest in the tomb.[26]

But let us see the remaining works in Venice. In the

(23) 1513; still in situ. Ill. p. 30 (24) 1507; still in situ. Ill. pp. 10-11
(25) *c.* 1505-10; Murano, San Pietro Martire. Ill. opposite
(26) 1488; known as the Paliotto Barbarigo. Murano, San Pietro Martire. Ill. pp. 32-33

Opposite: Assumption of the Virgin, c. 1505-10

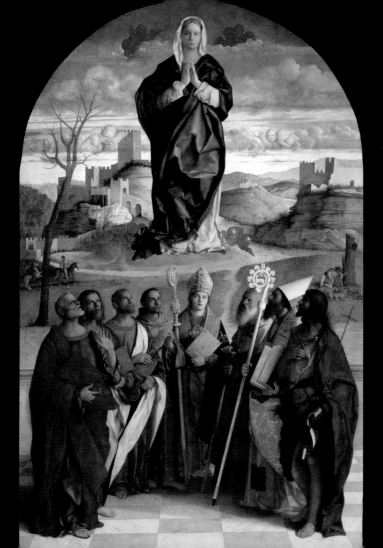

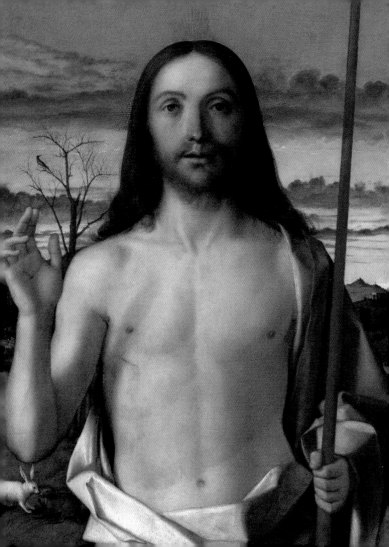

chapel of the Sacrament in San Salvatore is Christ at the table with Lucas and Cleophas, and with them is a Venetian gentleman, and a beggar asking for alms, very naturally painted, but above all the figure of the Lord conveying divine sentiments.[27] In the Old Church of the Capuchin Fathers on the Giudecca, Giovanni painted a small panel of the Most Holy Virgin Mary with St Francis, in which he portrayed the Father Guardian from life, resembling in this work what Giorgione did; or as some say, he liked the manner of his pupil.[28]

He made a gift to the fathers of Santo Stefano of an image of the Saviour in the act of blessing, a work extremely rare in both devotion and diligence, revealing the minutest of hairs and conveying the subtlest of sentiments in the face.[29] In the Procuratia *de ultra* he painted above the innermost door a noble figure of Our Lady, St Mark and three kneeling procurators.[30]

(27) Still in situ; now attributed to Carpaccio (28) Possibly the painting attributed to Rocco Marconi, now in Venice, Redentore (29) *c.* 1500; possibly the *Christ Blessing*, Hamburg, Galerie Hans. Different versions of the same subject survive, including the one ill. opposite, *c.* 1500, Fort Worth, Kimbell Museum (30) 1510; with workshop assistance. Baltimore, Walters Art Museum

Opposite: Christ Blessing, c. 1500

CARLO RIDOLFI

The Florentine gentleman Signor Bernardo Giunti
has a painting of the Saviour placed among four saints
with diligence and devotion in half figures,[31] and Si-
gnor Giovanni van Veerle, the Fleming, purchased a
singular effigy of the Virgin adored by Sts Peter and
Jerome in figures half the size of life.[32] We should
now record other things by this outstanding painter
which are outside Venice, his name not being ac-
claimed in one place alone, but taking flight in every
direction.

The citizens of Vicenza desired to honour their
church of Santa Corona with a great panel by that
delicate hand, of the Baptism of Christ.[33] Another fig-
ure of the Virgin Mary is found in the cathedral of
Bergamo,[34] and at Alzano, in the district of Bergamo,
is a similar image of Our Lady,[35] and in the church
of San Domenico in Pesaro is another panel, over the
high altar.[36]

(31) Lost (32) Lost (33) *c.* 1501-3, still in situ (34) Probably painting
by Cariani still in situ (35) *c.* 1485, known as *Morelli Madonna*;
Bergamo, Accademia Carrara. Ill. opposite (36) *Coronation of the
Virgin*, known as Pala di Pesaro, *c.* 1472-75, Pesaro, Museo Civico.
Upper section in Rome, Pinacoteca Vaticana. Originally in San
Francesco, not San Domenico. Ill. p. 17

Opposite: Virgin and Child (Morelli Madonna), c. 1485

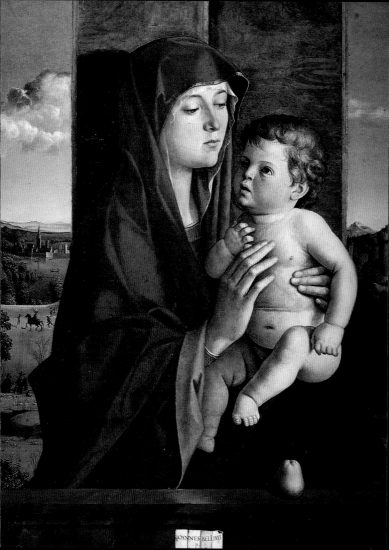

IOANNES BELLINVS

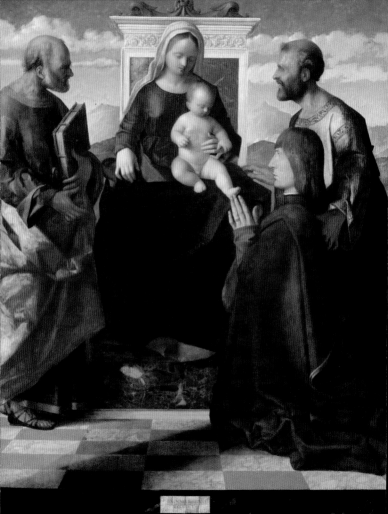

The Lord Archduke Leopold, who still lives and whose royal munificence is a continual gift to Painting, owns a divine image of the Virgin by Bellini.[37]

The Signori Cristoforo and Francesco Museli of Verona own, among the many things collected by their late father, two highly rare pictures by our artist, one in the form of an altarpiece containing the Queen of Heaven, with Sts Peter and Paul to the sides, and below, a portrait of a figure dressed *all'antica*, and at the top in the *coperta*, St Francis and St Vincent Ferrer;[38] the other is a Circumcision of the Lord in half-sized figures, beautiful and in excellent state, and with a portrait of Bellini himself.[39]

Many works were in past times collected by individual gentlemen, who held Giovanni's work in high esteem, and many works of his are in Rome, Germany, Flanders, and England, being universally desired for their delicacy and sweetness, for which he was particularly gifted. But it would be impossible to describe

(37) Possibly *Virgin* from the San Cassiano altarpiece by Antonello da Messina; Vienna, Kunsthistorisches Museum (38) Possibly *Virgin and Child, Saints and Donor*, 1505; Birmingham, City Art Gallery. Ill. opposite (39) Probably the *Circumcision*, c. 1500, with workshop assistance. London, National Gallery

Opposite: Virgin and Child, Saints and Donor, 1505

every one of them. We shall now touch on the ones housed in Venice.

In the house of the Grimani at Sant'Ermagora he painted in the great hall two large paintings of Cosmography, with figures of Ptolemy, Strabo, Pliny and Pomponius Mella, and inscribed his name thereon.[40] In the house of the Cornaro at San Maurizio is the Lord at Supper with Lucas and Cleophas, life-sized, painted by our artist for Signor Giorgio Cornaro, knight and brother of Queen Catherine, whom he portrayed in her mature years.[41] In the Loredan house at Santo Stefano is the portrait of Doge Leonardo Loredan seated at a little table, with two of his sons and others of his family, five figures in all, most vivid.[42] Among the pictures of the Procurator Morosini was a singular image of the Virgin and Child in the midst of some saints.[43] Another is in the house of Signor Lando, knight and most virtuous senator,[44] and one is owned by Signor Giovanni Salamone,[45] most worthy senator, and in the Zen house at the Crocichieri another similar devotional work.[46]

(40) Lost (41) The *Supper at Emmaus* is lost, but a portrait of Caterina Cornaro, *c.* 1500, by Gentile is in Budapest, Museum of Fine Arts (42) *c.* 1507; with workshop assistance, Berlin, Gemäldegalerie (43) Lost (44) Lost (45) Lost (46) Lost

One can see in various churches of this city a number of figures of the Virgin. In the Madonna dell'Orto,[47] San Girolamo[48] and in Santa Maria Maggiore[49] there are three painted in different ways, and in the Sanudo house is a painting containing the Most Holy Mary and St Joseph in a copse.[50]

Many are the portraits made by Bellini of personages and famous men, and doges of Venice, some of them portrayed in large paintings with other figures for the Sala del Collegio – of Bartolomeo Liviano [d'Alviano],[51] of Pietro Bembo[52] before he was cardinal, and for whom he also painted a portrait of one of Bembo's favourites,[53] who was celebrated in that portrait by the pen of that great writer:

> O my image, celestial and pure,
> you who shine in my eyes more than the sun
> and resemble the face of that woman,
> whom I carried into my heart engraved in every detail,
>
> I believe that with her semblance my Bellini
> also gave you her decorum,

(47) *c.* 1475; still in situ until stolen in 1993 (48) Lost (49) *c.* 1490; possibly the *Madonna dei cherubini rossi*, Venice, Accademia (50) Lost (51) Lost (52) *c.* 1505; perhaps *Portrait of a Man (Pietro Bembo?)*, Windsor, Royal Collection. Ill. overleaf (53) This portrait of Bembo's lover Maria Savorgnan is also mentioned by Vasari. Lost

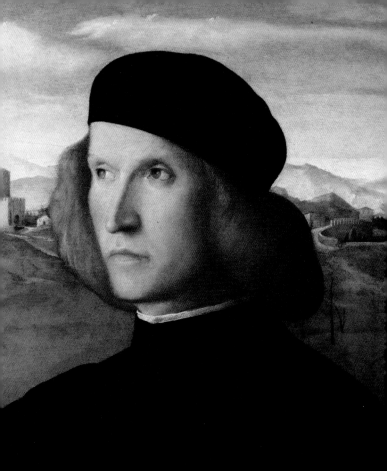

since you burn me if I look at you, though you are
essentially cold-hearted, touched by good fortune

And like a woman with a sweet, humble face
you really show pity for my torments;
then, if I ask mercy of you, you do not respond.

In this you have a less haughty style than her,
you don't scatter my hopes thus to the wind,
since at least, when I seek you out, you don't hide.

Are these the beauteous eyes in which I look,
and lose myself, with no defense to raise?
Is this the brow from which I often vainly ask
for mercy in my languishing?

Are these the tresses that do bind
my heart, which pines away?
O face! Impressed upon my soul,
so that I live, but ever banished.

Love is potently enthroned upon your brow:
on one side hover hope, delight,
and dread, and sorrow;

on other, strewn like stars across the sky
here and there appear
good judgement, merit, beauty, nature, art.

Opposite: Portrait of a Man (Pietro Bembo?), c. 1505

Finally, in his last years he began a composition for Alfonso I, Duke of Ferrara, with many bacchantes around a barrel of red wine with a drunken Silenus on the ass and young figures around them, which he did not finish because he died, though in order to complete it Titian added a beautiful landscape.[54] It is said to be in Rome with the Signori Aldobrandini, and is inscribed thus:

Ioannes Bellinus. M CCCCCXIV.

On this occasion he became well acquainted with Messer Lodovico Ariosto, who recorded him in the thirty-third canto of his *Furioso*, among the famous painters, in these verses:

With others that in these our later days
Have liv'd, as Leonard and John Belline*

But having attained his ninetieth year, and the highest level of honour for the excellent things he had done in his own country, and beyond, and having received the love of his citizens and garnered universal

* Translated Harington

(54) 1514; *The Feast of the Gods*, with landscape added by Titian in 1529. Washington, National Gallery of Art. Ill. opposite and detail pp. 112-13

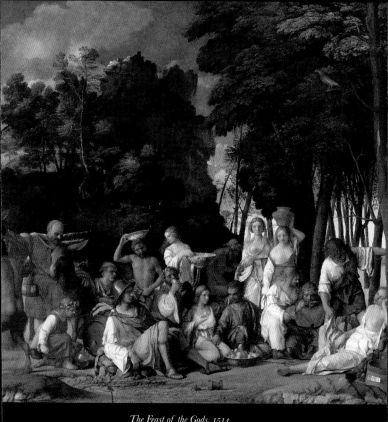

The Feast of the Gods, 1514
with landscape added by Titian, 1529

praise, Giovanni ended his life a victim of old age, which is no small happiness for those who likewise live long apart from those ills that are wont to be life's companions, in addition to so many human miseries. He was with great honour buried in the church of Santi Giovanni e Paolo, next to his brother, having been the foremost of all those who painted until his own time, and from his hands Painting received special gifts and sublime honours. His fame will renew itself from century to century until the world breathes its last.*

* Bellini died on November 29, 1516

MARCO BOSCHINI

Giovanni Bellini

from

The Map of Pictorial Navigation:
Dialogue between
a dilettante Venetian Senator
and a Professor of Painting

1660

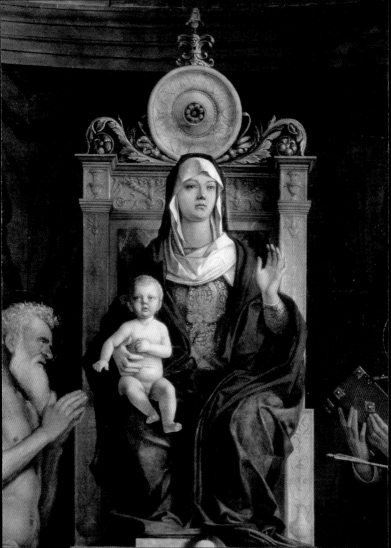

Giovanni was so learned, so worthy, that he may well be called the pinnacle of painters. What he's worth can be seen in San Giobbe, where there's an excellent work.

First, the beauteous majesty of Mother and Child, unprecedented in its form, so learned, and in conception so devout. You could certainly call it divine!

That dear Jesus, all splendour, and so natural, so well shaped, so beautiful, that anyone who sees Him would say the Redeemer is divinely portrayed.

The many saints are shown praying – a mirror of religion. First comes St Francis, compassionately showing beholders the wound in his side.

St Job stands in prayer, wholly devout and humble and modest; St John [the Baptist] attentive and sorrowful – I cannot think of a finer attitude.

And then there's St Sebastian, worthy martyr; and if anyone cannot see that pose, they cannot truly

Opposite: Virgin and Child, detail of San Giobbe altarpiece, c. 1480

see a single figure: it's flesh and blood, and all designed.

Studious St Dominic, poring over a book, so artfully depicted that it seems he is actually reading the pages; you can see his mind in meditation.

There's St Louis, Bishop [of Toulouse], crozier in hand, mitre on his head, solemnly robed for a feast day, showing the painter's learned genius.

But the three little angels are the condiment of this noble altarpiece, with their various instruments, and one can almost hear their musical harmony – it's all a gala here.

Seeing this concert ensemble moves one to stupor and confounds the finest minds. What invention, colour and draughtsmanship! True marvels, in the extreme.

And then to calm both Art and Nature with his genius and solid understanding, he's confined the

Opposite: Sts Dominic, Sebastian and Louis,
detail of San Giobbe altarpiece, c. 1480

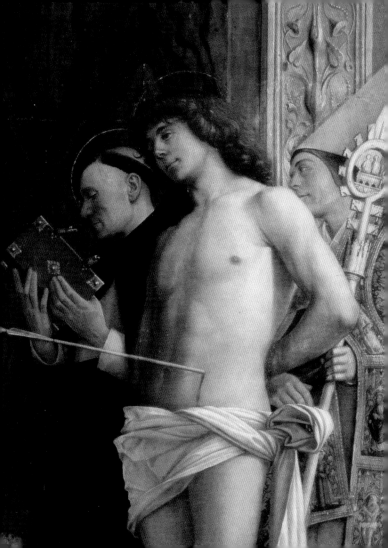

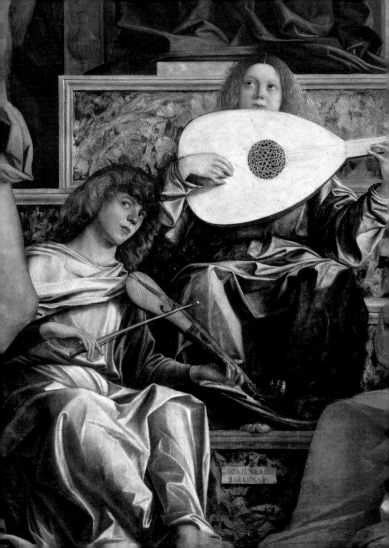

altar and its frame, with the painting adorned by Architecture.

He shaped the picture with arches and pilasters corresponding to the frame around it, of living stone, lovely and embellished, and even the *Protomastri* [Chief Architects] are deceived by the fiction that's within.

An altarpiece of such perfection that high praise goes to that paintbrush. If you wish you can count each hair that's painted, judicious and descriptive.

It can certainly be called a rarity! Invention, draughtsmanship, colour, freshness of handling, as I've already said: it stands quite unopposed, and has no fault.

*[The author's interlocutor
has three quatrains, omitted here]*

Bellini is a Raphael, at the very least – in ideas, forms and diligence. If you cannot stand him, be patient.

Opposite: Angels making music, detail of San Giobbe altarpiece, c. 1480

More than two have said it: his mind is a great one.

If anyone will not believe it's thus, take the San Zaccaria altarpiece, head and shoulders above Rome, and if you see it you'll agree with me.

When you use a touchstone to compare, you can tell copper from the fairest gold. May our Zambelin live on for ever, shining like a ray of painting [...]

[On the Stigmatisation of St Francis *in the Giustiniani collection, possibly the painting now called* St Francis in the Desert *in the Frick Collection]*

Giovanni Bellini represents the Seraphic Father [Francis of Assisi] imbued with divine zeal, and Christ appearing from the Heavens in the form of a Seraph all aflame.

Whoever sees such living sentiment (I'll steal a verse or two) will say: Francis matches Christ hand for hand, foot for foot, chest for chest.

Opposite: detail of St Francis in the Desert, *c. 1480*

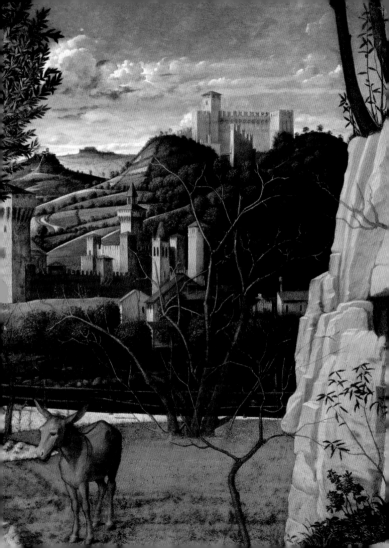

That mountain of La Verna, so eminent, is as natural,
 it seems to me, as its description by Maffeo Venier,
 Venice's poet so excellent.

Love itself is what Giovanni Bellini has used to il-
 lustrate painting, and make it eternal. Love, with
 more than paternal charity, favours such an out-
 standing painter.

And since all derives from Love – mankind, the ani-
 mals, and fruits and flowers – so Giovanni with his
 colours is the first to give a form to living painting.

Giovanni Bellini may be called the springtime of the
 whole world in the art of painting, for all that's
 green derives from him, and without him art
 would winter be.

Dry and sterile and destroyed, fruitless, without a
 flower of enjoyment; it would be a wretched tor-
 ment. But Love has sweetened all in Giovanni
 Bellini,

Opposite: detail of St Francis in the Desert, c. 1480

Overleaf: detail of The Feast of the Gods, 1514

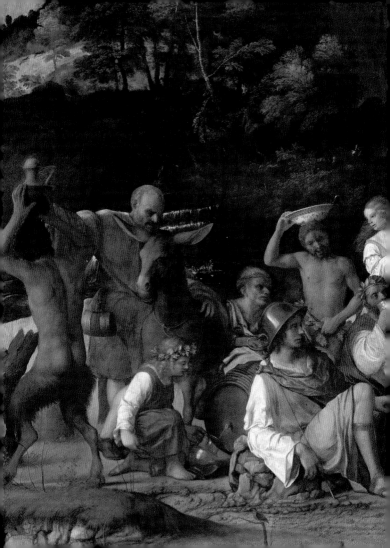

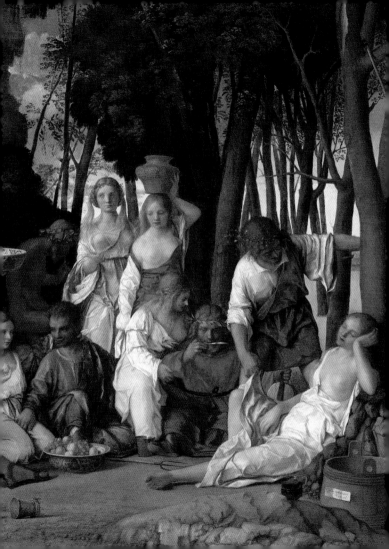

Producing green and fertile plants, the Goddess of
 Abundance has enriched with fruits of such es-
 sence and substance that taste and sweetness be-
 come one.

In short, the God of Love and Giovanni Bellini are
 sworn brothers, or better, twins – one with his
 arrows, the other with his brush, hitting home,
 contentedly.

Bellini is the oldest of Venetians, and white-haired
 Love is on crutches; and though it might seem a
 name that's just been born, he bears the centuries
 on his shoulders.

ISABELLA D'ESTE

*Correspondence with
Giovanni Bellini*

March 2, 1501 – May 13, 1506

Giovanni Bellini, c. 1500
Portait medallion by Vettor Gambello

*I*sabella d'Este (1474-1539), the highly cultured daughter of the duke of Ferrara, was married in 1490 to Federico, duke of Mantua. Shortly afterwards she decided to create a studiolo, a little study for intellectual pursuits to be decorated with works of art of the highest quality. In 1497 and 1502 Bellini's brother-in-law, Andrea Mantegna, supplied two large allegorical paintings of subjects from antiquity, Mars and Venus on Parnassus *and* Minerva Expelling the Vices from the Garden of Virtue. *But Isabella was already pursuing more fashionable artists, notably Perugino and Bellini himself. Her first contacts were initiated via the Venetian collector and connoisseur Michele Vianello, a friend of her favourite sculptor Gian Cristoforo Romano. Others involved were the great instrument maker Lorenzo da Pavia, and later the poet Pietro Bembo.*

VENICE, MARCH 2, 1501

Michele Vianello to Isabella: he has been entrusted by the marchioness to be the agent for a painting from Bellini, with whom he has discussed the terms of the commission

My most illustrious and excellent respected Lady,

On my arrival here I saw Giovanni Bellini about the commission Your Ladyship gave me at my departure. After telling him of the requirement and desire

of Your illustrious Ladyship and the story in the manner you wished, the said Giovanni Bellini replied that he was under an obligation to the illustrious government [of Venice] to continue the work he had begun in the palace; that he could never leave it from early morning until after dinner. However, he would make or steal time during the day to do this work for Your Excellency in order to serve you and for the sake of the love I bear him. I still warn you that the said Giovanni Bellini has a great deal of work on his hands, so that it will not be possible for you to have it as soon as you wanted. I am asking whether he will be able to get it done within a year and a half, and it will depend on how much he can do. As to the price, he asked me for one hundred and fifty ducats but he will reduce it to one hundred ducats, and this is all that can be done; so Your illustrious Ladyship knows what has been attempted in the matter. I await a reply from Your illustrious Ladyship, to whom I offer and commend myself forever. Please commend me to the illustrious Lordship of my Lord your husband

<div align="right">

Your most illustrious
and excellent Ladyship's servant
Michele Vianello

</div>

MANTUA, MARCH 10, 1501

Isabella to Vianello,
accepting the commission of one hundred ducats,
but not the deadline. Bellini and his workshop
are busy in the Doge's Palace

Messer Michele,*

If Giovanni Bellini wishes to come down to one hundred ducats to make that work of ours, about which you spoke to him, we shall be content with the price, but the term of eighteen months seems excessively long, and because we desire to see our *camerino* ['little room', i.e. the *studiolo*] finished soon, it would be a nuisance for us to wait so long. It would therefore dearly please us if you would beseech him to abbreviate his time, reducing it to one year, since with the work in the Palace of Saint Mark still in hand, and being the fine master he is, he will be able to use his time more advantageously, if he so wishes. As we have said, we are happy that with the agreed price of one hundred ducats, in which you would gratify us, offering ourselves, etc.

* 'Messer' is a title of respect, comparable to 'Master'

MANTUA, MARCH 28, 1501

Isabella to Vianello, urging a response from Bellini

Messer Michele,

In reply to your letter, we wrote a few days ago that when Giovanni Bellini reduced his price to one hundred ducats for making that picture for our *camerino*, in which we said we were happy as long as he abbreviated his time so we could have it in a year, it seeming too long to wait eighteen months for what we desired to have soon, but not having had news from you about the work you have done, we wanted to repeat to you our resolution, beseeching you that, not having carried out your request with Giovanni, you should do so, and give us notice of his deliberation by the courier of this letter. We offer ourselves, etc.

VENICE, APRIL 1, 1501

Vianello to Isabella, having spoken to Bellini, who has promised it within a year, starting after Easter, but requiring precise dimensions, as those given do not correspond to what was agreed, and asks for advance payment

Most illustrious and excellent lady, etc.,

I am responding to two letters from Your illustrious

Ladyship, which I have read with the greatest pleasure. I have been with Giovanni Bellini several times and told him Your Excellency's intentions, and he has agreed to do the work for one hundred ducats in a year's time. He promised me he would strive do it as soon as he could, and I hope that the term of one year will pass very quickly, so that Your Ladyship will be satisfied, and he promised to use every diligence so that Your Ladyship will be well satisfied.

I have learned of a measurement from Gian Cristoforo [Romano, Isabella's sculptor] of the length and width of the painting that does not match what Your Ladyship sent to Giovanni Bellini, and that another will have to be made.

Giovanni Bellini also spoke of Your Ladyship's pleasure to send him twenty-five ducats, and with the holidays over, he will begin the work.

I then await a response from Your illustrious Ladyship to whom I always commend myself, and to my Lord your consort, as you deign to commend me.

<div style="text-align:right">Your Ladyship's servulus [lowly servant]
Michele Vianello</div>

MANTUA, APRIL 4, 1501

*Isabella to Vianello, agreeing to accept Bellini's deadline
and to send twenty-five ducats*

Messer Michele,

I am pleased to hear about the time agreed by Giovanni Bellini for finishing the painting, and so that he may set to work in better spirits, after the Easter holidays have passed, I shall send the twenty-five ducats you have sought from us on his behalf. We always readily offer ourselves to your pleasure.

MANTUA, JUNE 23, 1501

Isabella urges Vianello to verify that Bellini has begun work

Messer Michele,

Having sent you twenty-five gold ducats through Cipriano our courier, which you must give to Giovanni Bellini the painter for promised and partial payment for the picture he will be making for our studio, we pray you to see to it that he begin the work, and please urge him to continue, so that having reached his limit of time, and sooner, if it were possible, he finish it, so we shall be grateful to both one and the other [of you], offering ourselves, etc.

Vianello to Isabella: Bellini is perplexed about the subject assigned to him, fears comparison with Mantegna and requests the marchioness let him choose the subject freely

My most illustrious Lady,

Today I have received your letter from Ziprian [Cipriano], Your Excellency's courier, and from the same I received twenty-five ducats to give Giovanni Bellini, who is at his villa. He will be back at his house here, they tell me, within five days. I will be with him immediately, and that Your Excellency may know that I have your service in mind, I have spoken to him several times about this picture. He told me that he was very anxious to serve Your Ladyship, but about the story Your Ladyship gave him, words cannot express how badly he has taken it, because he knows Your Ladyship will judge it in comparison with the work of Master Andrea [Mantegna], and for this reason he wants to do his best. He said that in the story he cannot devise anything good out of the subject at all and he takes it as badly as one can say, so that I doubt whether he will serve Your Excellency as you wish. So if it should seem better to you to allow him to do what he likes, I am most certain that Your Ladyship will be very much better served. Therefore I beg

Your Ladyship will be pleased to give me your views, because he will not do anything until I hear from you.

From Your Ladyship's servant

Michele Vianello

MANTUA, JUNE 28, 1501

*Isabella to Vianello, accepting Bellini's choice of subject as long
as he paints a story from antiquity, urging its completion,
and underlining that dimensions remain unaltered*

Messer Michele,

If Giovanni Bellini is so unwilling to do this *historia*, as you write, we are content to leave the subject to his judgement so long as he paints some ancient story or fable with beautiful meaning. We should be very glad if you would urge him to make a start on this work, so that we have it within the time he has estimated, and sooner if possible. The size of the picture has not been altered since you were here and saw the place where it was to go. Nevertheless, to be on the safe side I am sending you the measurements again, and Gian Cristoforo [Romano] our sculptor will write to you about this. Be as scrupulous in this matter as we hope you are.

VENICE, AUGUST 3, 1501

Lorenzo da Pavia to Isabella: Bellini is being urged to work, and he has completed a small picture for her brother, the duke of Ferrara

The painting by Giovanni Bellini is being solicited with all diligence. Just now he has finished a half-length figure of St Dominic, which is very beautiful, in a small painting, made for Lord Don Alfonso [d'Este].

VENICE, AUGUST 27, 1501

Lorenzo da Pavia to Isabella: Bellini is to paint a fantasia, *and he apologizes for not having started, engaged as he is on work in the Doge's Palace*

Giovanni Bellini says he is going to make a beautiful *fantasia* for Your Ladyship's painting, but he has not yet begun it. He is a man who takes his time, and excuses himself because he still has painting to do in the Palace, but he will attend to both one task and the other.

If Your Ladyship is in Florence, have Perugino make a painting, he is an excellent master and a friend of Giovanni Cristoforo Romano.

MANTUA, DECEMBER 20, 1501

Isabella to Vianello: there is no news from Bellini, and she contemplates the possibility that he has not begun the work, in which case he should return the twenty-five ducats

Messer Michele,

After we sent you the twenty-five ducats to be given to Giovanni Bellini, we never heard whether he began our picture, of which he ought to have already done a good part, if it was to be finished within one year. May it please you to see him and let me know where things stand, encouraging him to continue so that we may have it within the promised time. But if he has not yet begun, and you were to know that he would not, or could not, fulfil our promise, see to it that he returns our money and send it to us so that we may carry out our wishes in another way, as we desire above all to see our *camerino* completed.

Offering ourselves, etc.

VENICE, JANUARY 4, 1502

Vianello to Isabella: Bellini is very busy and unwell

On the 22nd of the last month [December 1501] I received a letter from Your Ladyship in which you tell

me of the painting being made by Giovanni Bellini, and whether it is completed within the year, and if not, that I should have him give back the twenty-five ducats.

I have been with the said Giovanni Bellini, who told me that if Your Excellency were content to wait to the end of September, it will be finished without fail.

Were Your Ladyship content to await that long, the said Giovanni Bellini, who has been much occupied, and has also been sick for many days, asks if it may please you to tell me if you are not content with these terms, and I shall have the money returned to me and bring it to Ferrara, to Your Ladyship, to whom I am always obliged.

MANTUA, JANUARY 15, 1502

Isabella to Vianello, concerned about the painting commissioned from Bellini and convinced he will be unable to respect the agreed terms of delivery

Messer Michele,

If Giovanni Bellini promises to deliver the painting to me finished in September, as I had written, we would be content to leave him the twenty-five ducats, but if

we trust him we could calm our soul by having it on time. May it please you to solicit him and occasionally let me know what he is doing, which we would be grateful to hear from you, to whom we are obliged, etc.

MANTUA, AUGUST 10, 1502

Isabella to Vianello, urging him to verify that Bellini has begun painting, otherwise she will ask for the twenty-five ducats to be returned

Messer Michele,

If Giovanni Bellini has not already begun our painting, make him return the twenty-five ducats we had given him, because we believe he could not do it according to the time he promised, and we no longer wish to be at his discretion. Even if he has begun it and is waiting to work on it, according to the way you had judged would satisfy us, we are happy to leave him the money and you should keep soliciting him, otherwise as we have said return them to us so we may think again, and we offer ourselves, etc.

VENICE, AUGUST 31, 1502

*Lorenzo da Pavia to Isabella: in spite of solicitations, Bellini
has not begun the painting; Lorenzo fears he will never do so,
not being "omo per fare istorie"*

Regarding the painting that Giovanni Bellini was to
make, he has done nothing at all! Not indeed for want
of constant entreaties both on my part and on that of
Messer Michele, but I always thought, as I told Your
Ladyship, that he would never paint this picture. He
is not the man for these subjects (*istorie*). He says that
he will do them but never does! By way of helping on
matters, I asked one of my friends, a poet of talent,
to invent a very simple theme which could easily be
painted, and which I now enclose, but even thus, I
fear, he will never undertake the work, and Messer
Michele will therefore ask him to return the twenty-
five ducats, and advise Your Ladyship about every-
thing, and commends himself to you. That is all.

 I commend myself, etc.

If Your Ladyship wanted to have a beautiful work of
painting, Perugino, who is in Florence, would do it swiftly
and as well as the [best] man in Italy.

VENICE, SEPTEMBER 10, 1502
Lorenzo da Pavia to Isabella

Most illustrious Lady

[…] As for the money, Your Ladyship must understand that it is difficult to make the painter give back the ducats. Now he pretends that he will paint you a charming *fantasia* after his own fashion, which is, it must be confessed, a rather lengthy fashion! Messer Michele begs you to write him a letter which he can show the painter, and will compel him to restore the money.[…]

MANTUA, SEPTEMBER 15, 1502
Isabella to Vianello: she is disappointed, Bellini should no longer undertake the work, and she has lost interest.
*He should paint the Nativity (*presepio*)*

Messer Michele

You may remember that many months ago we gave Giovanni Bellini a commission to paint a picture for the decoration of our studio, and when it ought to have been finished we found it was not yet begun. Since it seemed clear that we should never obtain what we desired, we told him to abandon the work

and give you back the twenty-five ducats which we had sent him before, but now he begs us to leave him the work and promises to finish it soon. As till now he has given us nothing but words, we beg that you will tell him in our name that we no longer care to have the picture, but that if instead he would paint a Nativity, we should be well content, as long as he does not keep us waiting any longer, and will count the twenty-five ducats which he has already received as half payment. This, it appears to us, is really more than he deserves, but we are content to leave this to your judgement. We want this Nativity to include St Joseph and St John the Baptist and the [customary] animals near the Madonna and Our Lord God. If he refuses to agree to this, you will ask him to return the twenty-five ducats, and if he will not give back the money you will take legal proceedings, and we assure you that we shall be deeply obliged to you for your efforts with him, offering ourselves, etc.

VENICE, OCTOBER 15, 1502

Vianello to Isabella, reassuring her that he has told Bellini about her wish for a Nativity, and that he has said he will do it

I received a letter from Your Excellency these past few

days in which you asked me about the painting by Giovanni Bellini, who could not be found anywhere during that time, and for that reason I did give Your Ladyship a response, because it was expected soon. Now he has come and I have spoken to him, and he says he is happy to make the Nativity and excellent things, and if Your Ladyship wished him to work on the canvas that was prepared for your *camerino*, he will begin immediately, and he asks the same price as he had asked for the *historia*, that is, one hundred ducats. Thus if Your Ladyship is content, advise me and I shall do as you say, for I only desire to do what pleases Your illustrious Ladyship, to whom I always humbly commend myself. And if by chance Your Ladyship did not want to have the canvas painted, Giovanni Bellini is ready to return Your Ladyship's money. […]

Your Ladyship's servant

MANTUA, OCTOBER 20, 1502

Isabella to Vianello, regarding the commission of a Nativity to Bellini. With a new subject and placement, the dimensions should be reduced and the cost limited

Messer Michele,

We are happy that Master Giovanni Bellini should

make us a Nativity instead of the *historia*, and that he is content with this, according to the letters you have sent us. But our wish is that this should not be as big as we intended for the *historia*, but rather of the dimensions that will be given you by Battista Scalona, secretary of the Illustrious Lord our consort and bearer of this letter, because our intention is to place it in a bedchamber. As for the price, we do not think it is appropriate that he should be given as much as we had offered for the *historia*, in which more figures appear than will be in the Nativity. You could offer him forty or fifty ducats, which seems an honest price to pay, yet without depriving yourself of the freedom to offer him more or less, according to what he may deserve, and, by God, ask him to give us satisfaction very soon, and as we desire. If he were inclined to abandon the Nativity, and create some other new Marian invention, we would be content to allow it. The truth is that we would be happier with the Nativity, as you will hear in greater detail from the aforementioned Battista, who is fully informed of what we have in mind. We are most obliged to you.

VENICE, NOVEMBER 3, 1502

Vianello to Isabella, informing her of the agreement with Bellini regarding the Nativity, its figures and price

Most illustrious and excellent Lady

I have just received a letter from Your Ladyship in which you tell me about the picture by Giovanni Bellini. I have had the measurements of the picture from Messer Battista Scalona and I at once went to find him and tell him Your Ladyship's wish about the Nativity scene, and that Your Ladyship wished a St John the Baptist to appear in the scene. He replied that he was happy to serve Your Excellency, but that the said saint seemed out of place in this Nativity, and that if it pleases Your illustrious Ladyship he will do a work with the infant Christ and St John the Baptist and something in the background with other fantasies which would be much better. So we left it at that: if this pleases Your Ladyship please let me know, because I will do whatever Your Ladyship commands. As to the price, he agreed to take fifty ducats, and anything more which may seem fair to Your Excellency. So I ordered the canvas to be primed and he promised to begin very soon. That is all for the time being. I humbly commend myself to Your illustrious Ladyship.

MANTUA, NOVEMBER 12, 1502

Isabella to Vianello

Messer Michele,

As Bellini is resolved on doing a picture of the Madonna and Child and St John the Baptist in place of the Nativity scene, I should be glad if he would also include a St Jerome with the other inventions which occur to him; and regarding the price of fifty ducats we are content, but above all urge him to serve us quickly and well.

MANTUA, NOVEMBER 22, 1502

Isabella to Vianello, accepting that Bellini should paint the Nativity as he wishes, either on canvas or panel, according to agreed dimensions

Messer Michele,

Although we recently wrote to you that you should have a picture of the Madonna and those other saints made in exchange for the Nativity we wanted Bellini to make, we are nonetheless content that he should make the Nativity for us without a St John the Baptist, if that pleases him. We made the change fearing he was reluctant to accept painting the Nativity,

which we strongly desire, rather than have nothing at all. You should urge him to start, and make it as he pleases, as long as it is beautiful and corresponds to his renown as a painter. As for how he paints it, whether on canvas or wood panel, we leave that up to him, as long as it is of the measure and size we sent you.

Farewell.

VENICE, OCTOBER 6, 1503

Lorenzo da Pavia to Isabella: Bellini's painting will soon be finished

I have been to see Giovanni Bellini, and he says he will not fail to have Your Excellency's painting finished in a month and a half, and that he does not wish to cease work on it until it is done.

VENICE, OCTOBER 8, 1503

Francesco Malatesta to Isabella: Bellini's painting will soon be ready, but no one has seen it because he never shows anything incomplete

My most illustrious Lady

Master Lorenzo has given me to understand that it will not be possible for me to see the painting on which Giovanni Bellini is working because he never

shows to anyone anything of his that is not finished, but the painting will in any event be completed this coming month.

Lorenzo da Pavia to Isabella: Bellini's painting will be finished in one and a half months, because pigments do not dry well in winter

Most illustrious and excellent Lady

Regarding the painting by Giovanni Bellini. I continually urge him, though this may be of little value to me, but he has promised me that in a month and a half he will be finished, and says that during wintertime colours do not dry well. That is all. I commend myself as Your Excellency's most faithful servant.

<div align="right">Farewell.</div>

Isabella to Alvise Marcello, seeking his intervention and a return of the twenty-five ducats, so as to make amends for Bellini's offense

Magnificent Lord, etc.

Three years have passed since we gave the painter Giovanni Bellini twenty-five ducats as an advance

and part payment for an *historia* he had undertaken to make, to be placed in our studio. Thereafter, declining to make this *historia* he agreed to make me a Nativity of the Saviour for the said twenty-five ducats, as Michele Vianello and Lorenzo da Pavia have been fully informed. He has never satisfied us, nor do we believe he intended to have it finished to give to us, as we knew not where to proceed, unless it was to hold us in low esteem.

The master has never kept any of his promises and does not, it is plain, intend to keep them. We hardly know what steps to take next, but we see clearly how little is the respect which the painter has shown us. Bellini has never considered his obligations to us and we are determined to have our money back. As there is no one in Venice whom we trust more than you, we have thought it best to ask you to desire Bellini to return our twenty-five ducats without accepting either excuses or promises, for we will have no more of his work. If he refuses, I beg of you not to shrink in this extremity from saying words to the Prince, or to any magistrate who can order an execution, so that he may not be allowed to insult us in this fashion. If he refuses to give back the money, which we can hardly believe, you might appeal to Michele Vianello or Lorenzo da Pavia; and Your Magnificence may rest assured that

you can do us no greater service than to recover our money, and, what is of far more importance, prevent Bellini from doing us so great an injury.

Offering ourselves, etc.

MANTUA, APRIL 10, 1504

Isabella to Lorenzo da Pavia, beyond impatience:
Alvise Marcello should recover the money

Lorenzo,

We can no longer endure such villainy as Giovanni Bellini has shown us regarding this picture or panel of the Nativity which he agreed paint for us, and we have decided to recover our money, even if the picture is finished, which we do not believe. I have written to the Magnificent Messer Alvise Marcello, our *compatre*, begging him to claim the money, and if Bellini refuses to return it, compel him to do so by the command and authority of His Most Serene Highness the Prince [Doge Leonardo Loredan]. You will therefore beg His Magnificence to do this office, in order that we may get out of the hands of this ungrateful man.

Greet Michele Vianello, and farewell.

VENICE, JULY 2, 1504

Giovanni Bellini to Isabella,
apologetically

Most illustrious Lady,

If I have been slow to satisfy the wish of Your Highness which was no less my own, and you have found it tedious to wait so long for the promised picture, I beg your pardon on bended knees praying you of your wonted kindness to attribute this delay to my innumerable occupations, and not to any forgetfulness of Your Excellency's orders, which are graven in my heart continually, since I am your most devoted servant; and I pray God that if I have not satisfied Your Highness in point of time, you may at least be content with the work, and if this does not satisfy your great wisdom and experience, you will describe my failure to the weakness of my own poor powers. Humbly commending and offering myself.

<div style="text-align:right">

Your most humble servant
of this Dominion,
Giovanni Bellini the painter

</div>

VENICE, JULY 6, 1504

*Lorenzo da Pavia to Isabella: Bellini has finished the painting
and it is beautiful*

Most illustrious and excellent lady,

I have been to Bellini several times with the Magnificent Alvise Marcello to ask for the return of the money without being able to effect anything, but this morning I went back and saw the picture which is really finished and wants nothing. And it is indeed a beautiful thing, even finer than I could have expected, and will, I am sure, please Your Excellency. The painter has made a great effort to do himself honour, chiefly out of respect to Messer Andrea Mantegna, and although it is true that in point of invention it cannot compare with the work of Messer Andrea, that most excellent master, I pray Your Excellency to take the picture both for your own honour and also because of the merit of the work. He need not lose his money in any case for I have found a purchaser who will give me the money for you, but I will do nothing until I hear from you and perhaps it may not come to anything.

Although the said Giovanni has behaved so badly that he could not possibly have acted worse, his excuses are not altogether without reason, and Your

Highness must accept his excellence and forget his ill conduct. And I say this because his works are among the finest in Italy, and all the more because he is growing old and will only become feebler. If you wish it, he will have a most beautiful frame made for the picture, and take its measurements before we send it to you [...].

<div style="text-align:center">

MANTUA, JULY 9, 1504

Isabella to Lorenzo da Pavia: she intends to buy
the painting, and is sending twenty-five ducats
via her secretary Scalona

</div>

Lorenzo,

Since Giovanni Bellini has finished the picture and it is as beautiful as you tell us, we are willing to take it and send you the twenty-five remaining ducats, to complete the payment, by our secretary Battista Scalona. Please have it prepared so that it may travel conveniently and without danger, delivering it to the said Scalona.

MANTUA, JULY 9, 1504

Isabella to Giovanni Bellini

Messer Zoanne Bellino,

If the picture which you have done for us corresponds to your fame, as we hope, we shall be satisfied and will forgive you the wrong which we reckon you have done us by your slowness. You will deliver it to Lorenzo da Pavia, who will pay you the twenty-five ducats owing on completion of the work, and we beg you to pack it in such a way that it can be carried here easily and without risk of damage. If we can oblige you in anything we will willingly do so when we have seen that you have served us well.

Farewell.

VENICE, JULY 16, 1504

Lorenzo da Pavia to Isabella: payment and preparations for shipping Bellini's finished painting

Illustrious Lady,

Through Scalona I have received the twenty-five ducats for the remainder of the painting, and promptly discovered that Giovanni Bellini was still owed one ducat, since initially Vianello had not given him more

than twenty-four, and so I asked Messer Michele. He said it was true, and that he had spent that ducat on a painting he had had made before, of the size of those going into the *camerino*, but I do not know anything else about that panel because he never tells me anything; I believe Giovanni Cristoforo [Romano] must know this. So I had to give this extra ducat, and more, for the expense of the waxed cloth to cover the said painting, and other minor expenses, [to the amount of] six *marcelli*. I had the measurements of the said picture taken by the master who made the hand-cart, [and?] if Your Ladyship wishes to have made for it a fine gilded frame with some fine carving it can be done without altering the picture any further.

I have bought an ounce of musk that cost six and a half ducats, of the best that may be found at the moment. Scalona was there and I delivered everything to him. You will have received the two ebony rods which I sent by a Mantuan boatman. Messer Pietro Bembo commends himself highly to Your Excellency. Every hour seems like a thousand as I await news of how Your Ladyship will have liked this painting. It is indeed a beautiful thing, though if I had ordered it I should have preferred larger figures. And as I have written before, with respect to invention no one can rival Andrea Mantegna, who is truly most excellent

painter, and the first [of painters]. But Giovanni Bellini excels in colouring, and all who have seen this little picture have praised it as admirable; it is highly finished and will bear close inspection.

That is all for now.
I commend myself, etc.
Farewell.

VENICE, AUGUST 13, 1504

*Lorenzo da Pavia to Isabella, giving his opinions of
Bellini's painting*

Most illustrious Lady

By a letter of yours I have understood that Your Excellency liked the painting, which has given me the greatest pleasure, although the figures are too small. It seems to me that the weak point here was not having the painter make two or three drawings from which one could have a better idea. But nothing was ever said to me, and he would never show me his work; if I had seen it I might have had him modify some of it. And I was surprised by the panel, which is a sad thing, and if the picture could speak, it would complain of being on such a sad panel; or maybe it is my nature that I am never fully satisfied by anything, starting

with my own deeds. I have received the money for the musk, and for what remains for the painting, which is good […].

Farewell.

VENICE, AUGUST 27, 1505

Pietro Bembo to Isabella regarding the painting
she intends to commission from Bellini
for the studiolo

[…] I have not forgotten that I promised, if possible, to induce Giovanni to paint a picture for Your Ladyship's *camerino*, in which matter I have been greatly helped by Messer Paolo Zoppo, a loyal servant of Your Ladyship and a dear friend of Bellini. In fact, we have stormed of the castle with so much vigour that I believe it will shortly surrender. All that we now require to make the victory complete is that Your Ladyship should write a warm letter to the master, begging him to oblige you, and if you send it to me, you may be sure it will not have been written in vain […].

Your most illustrious Ladyship's servant,

Pietro Bembo

MANTUA, OCTOBER 18, 1505

Isabella to Bellini, has much appreciated the Nativity

Messer Zoanne,

You will remember very well how great our desire was for a picture of some story painted by your hand, to put in our studio near those of your brother-in-law Mantegna; we appealed to you for this in the past, but you could not do it on account of your many other commitments. Instead of the story which first you had promised to do, we resigned ourselves to taking a Nativity scene instead, which we like very much and are as fond of as any picture we possess. But the Magnificent Pietro Bembo was here a few months ago, and hearing of the great desire which we cherish continually, encouraged us to hope it might yet be gratified. He thought that some of the works which have been keeping you busy had now been delivered, and knowing your sweet nature in obliging everyone, especially those in high places, he was able to promise us satisfaction. Since the time of this conversation we have been ill with fever and unable to attend to such things, but now we are better it has occurred to us to write begging you to consent to painting a picture, and we will leave the poetic invention for you to make up if you do not want us to give it to you. As well as the

proper and honourable payment, we shall be under an eternal obligation to you. When we hear of your agreement, we will send you the measurements of the canvas and an initial payment.

<div align="center">

MANTUA, OCTOBER 18, 1505

*Isabella to Pietro Bembo, requesting he forward
a letter to Bellini*

</div>

Magnificent and most honoured Messer Piero,

We apologise to Your Magnificence for not having replied earlier to your letter. Our secretary Benedetto Codelupo will have notified you of the reason for the delay, but now that we can begin to attend to business we want to thank you for what you wrote, for which I was very grateful – most of all for the hope that it gave me to be able to have a painting by Bellini, to whom, following the suggestion of Your Magnificence, we wrote in the attached letter, in the appropriate manner. We pray you, since you have been kind enough to take on this task, to deliver our letter to him, with your authority, which will have greater strength with him, to render him disposed to satisfy us. I could not have a greater pleasure from Your Magnificence, to whom we offer, etc.

MANTUA, NOVEMBER 8, 1505

*Isabella to Bellini, regarding the new painting
she wants for her* camerino

Messer Giovanni,

We are very happy to hear that you are willing to satisfy our intense desire, and paint the picture about which we wrote lately. Nothing will please us more than to have a work from your hand. We will have the measurements taken and will send you particulars of the lighting, according to the place where the picture is to hang. And since the Magnificent Pietro Bembo is soon returning to Venice, and has seen the pictures in our *Grotta*, he will be able to decide on the subject with you. We will then send you the earnest money, and beg you to persevere in your present kindly intention towards us.

Offering ourselves, etc.

VENICE, NOVEMBER 20, 1505

Pietro Bembo to Isabella

Having just returned from the March, where I spent some time, I find your ladyship's letters on the subject of Bellini's picture, in answer to mine, which are

already old. And I also hear that Paolo and Lorenzo, both of them good servants of Your Highness, have been diligent in my absence. But today I have been to see Giovanni, and find that he has firmly resolved to gratify your wish, which I am sure he will do admirably. He only awaits your answer as to the size and lighting of the picture.

<div style="text-align:right">

I commend myself, etc.

Your most illustrious Ladyship's servant,

Pietro Bembo

</div>

<div style="text-align:center">

MANTUA, DECEMBER 2, 1505

Isabella to Pietro Bembo about Bellini's new painting

</div>

Magnificent Messer Pietro,

We were glad to hear from the letter of Your Magnificence that you had reached Venice safely, and feel sure that, as you grieved over our sickness, so you will have rejoiced over the fortunate birth of our son, since we are persuaded that you love us with the same fraternal affection that we feel for you. We thank you sincerely for your good offices with Bellini, and beg you to keep an eye upon him until we are able to leave our bed, and send him the necessary directions for the size and lighting of the picture. At present, you might

remind him to finish any of that works upon which he is engaged, in order that, after the Christmas festival, he may be able to attend to our affairs without distraction. I hope Your Magnificence will not object to choosing the subject of a *fantasia* which may satisfy Bellini. Since you have seen the other pictures in our *camerino*, you will know what is most appropriate, and will be able to choose a graceful theme of new and different meaning. You can, we repeat, do us no greater pleasure than this, of which we shall ever remain mindful and as before most ready to serve you.

VENICE, JANUARY 11, 1506

Pietro Bembo to Isabella, offering support; also about
Mantegna and the Corners

I have been with Bellini recently and he is very well disposed to serve Your Excellency, as soon as the measurements of the canvas are sent to him. But the invention, which you tell me I am to find for his drawing, must be adapted to the fantasy of the painter. He does not like to be given many written details which cramp his style; his way of working, as he says, is always to wander at will in his pictures, so that they can give satisfaction to himself as well as to the

beholder. Nevertheless, he will achieve both ends by hard work.

In addition to this, spurred by my great devotion and service to Your Excellency, I beg your good offices about a matter which I have much at heart, with as great a hope of being heard as the desire I always have to do you service. With Messer Francesco Cornelio, brother of the most reverend Cardinal, I observe a close kinship and a most dear and familiar friendship, no less than if he were my brother. He has in addition many very singular qualities, so that I hold him infinitely high in honour, and desire to please him. Since he is, like all lofty and gentle souls, passionately fond of rare things, he arranged some time ago with Messer Andrea Mantegna to have several canvases painted for him at the price of one hundred and fifty ducats. He gave him an advance of twenty-five ducats, having first sent him the measurements, and the work was welcomed by Messer Andrea, so that he went ahead. Now he tells me that Messer Andrea refuses to go on with it for that price, and asks a much larger sum, which seems to Messer Francesco the greatest novelty in the world, as it appears to everyone he tells about it. This is especially so because he possesses letters of Messer Andrea in which he particularly confirmed the said agreement they made

together. Messer Andrea alleges that the work turns out to be bigger than he had estimated, so he wants more payment. I therefore beg and implore Your Ladyship to persuade Messer Andrea to keep faith with Messer Francesco and make a start on the pictures he has undertaken for him; above all he should be reminded that he who is called the *Mantegna* by the (whole) world ought above all men to keep [*mantenere*] his promises, so that there should not be the like discord when he does otherwise, being and not being Mantegna at the same time, if I may be allowed to make puns [*motteggiare*] with Your Excellency. Francesco does not take issue about one hundred or two hundred florins for something which merits so little gold (thank God he has abundant means for a man of his rank), but takes issue against being made a fool of and derided. Should Your Excellency think that the work, once delivered, deserves a much higher reward, he will act in such a way that Messer Andrea will not be able to call him boorish, and he wants to stand by Your Ladyship's judgement, and that she should commit him to whatever seems right and pleasing to her. But that he should now say – the bargain having been arranged long ago and the advance payment accepted – "I no longer want it thus, but like this; do not imagine that the work is going ahead" – Messer

Andrea should for God's sake see that these matters are no more burdensome to him than damaging to Messer Francesco, who would not want his pictures except that it is a very important issue for him. Messer Francesco is in no doubt of obtaining this favour from you by my intercession, reckoning that I can do much more with you and that Messer Andrea should and can deny you nothing. It will be most highly appreciated by me if Your Ladyship deigns to act in such a way that Messer Francesco is confirmed in the estimated price; it will show that I am not excluded from the grace of Your most illustrious Ladyship, which [token] I will certainly receive in place of a very great benefice. I hope also that Messer Andrea's courtesy and good nature, from which two virtues he never strays far, will mean that Your Ladyship has little trouble in this task. Nevertheless I promise you that all the help Your Ladyship gives in resolving the matter of Messer Francesco's pictures with Messer Andrea Messer Francesco will gratefully repay by helping on your business with Giovanni Bellini, with whom he is usually able to do a great deal. In the meantime he and I remain obliged to Your most illustrious Ladyship, to whose grace we both kiss our hands.

Your most illustrious Ladyship's servant

Pietro Bembo

MANTUA, JANUARY 31, 1506

Isabella to Pietro Bembo about the new painting by Bellini;
Mantegna is ill

Magnificent Messer Piero,

We are delighted to hear that Bellini is going to do the picture, and recognize that this is owing to Your Magnificence. We will find out the particulars of the size and the lighting, and will send them to you, together with the deposit money. Meanwhile we beg you earnestly to settle the subject with the painter. Messer Andrea Mantegna has been very dangerously ill these last days. He is very near his end, and although just now he is a little better, it is impossible to speak to him of pictures, or of anything but his health. If he recovers we will see that the Magnificent Francesco Cornelio receives satisfaction [...].

SACCHETTA, MAY 11, 1506

Isabella to Pietro Bembo: she will send the measurements for
Bellini's painting; she regrets the death of Michele Vianello,
and is interested in purchasing works he owned

Magnificent Messer,

Perhaps Your Magnificence will be surprised that

we have not yet sent you the measurements for the painting that Bellini is to make. Do not believe my appetite is lacking – the delay was caused by a sudden outbreak of plague in Mantua, and having just returned from Florence, we had to leave Mantua promptly without having the measurements taken. Your Magnificence should not cease from keeping Bellini in readiness, and to compose the poetry to his satisfaction, because when the plague has gone as much as possible, we shall send the measurements of the picture and of the figures, and the advance payment.

Having heard that Messer Michele Vianello has died, we were unhappy for the loss of his virtues and the affection he had for us. We remember having seen in his house an agate vase and a painting of the Drowning of Pharaoh, which we desire to have. We have entrusted Taddeo Albano and Lorenzo da Pavia, that needing the favour of a man of authority, they should turn to Your Magnificence; but we pray you that where it is needed, we are pleased with what we have spent, since this will be one of the great pleasures you can do for me. Offering, etc.

VENICE, MAY 13, 1506

Pietro Bembo to Isabella (in Sacchetta), reassuring her
about the Bellini commission

Reverently, I have just now received the letters of Your most illustrious Ladyship, and understand your wish to have the agate vase and the Drowning of Pharaoh that belonged to Vianello. I shall see Messer Taddeo Albano and Lorenzo da Pavia, and if the need arises I shall endeavour to satisfy Your Excellency, as is my bounden duty. As for Bellini, I will not fail to obey you. I was very sorry to hear of the plague at Mantua, which deprived me of the pleasure of paying my respects to Your Highness this Easter, which was the chief object of my journey.

I kiss Your Ladyship's hand.
Your illustrious Ladyship's servant
Pietro Bembo

List of illustrations

pp. 52-53: Virgin and Child with Sts Nicolas of Bari, Peter, Mark and Benedict (Frari altarpiece), 1488, oil on panel, 184 x 79 cm, Venice, Santa Maria Gloriosa dei Frari

p. 55 : Dead Christ in a Landscape, c. 1510, oil on panel, 107 x 70 cm, Stockholm, Nationalmuseum, n. 1726

p. 61: Portrait of a Young Man in Red, c. 1480, oil and tempera on panel, 32 x 26.5 cm, Washington, National Gallery of Art, Andrew W. Mellon Collection, n. 1937.1.29

pp. 64-65: Pietà with Four Angels, c. 1470-75, tempera (and oil?) on panel, 80.5 x 120 cm, Rimini, Pinacoteca Comunale

p. 68: Young Woman with a Mirror, 1515, oil on canvas, 62 x 79 cm, Vienna, Kunsthistorisches Museum

p. 73: Virgin with Child (Contarini Madonna), c. 1475-80, oil on panel, 78 x 58 cm, Venice, Accademia, n. 594

p. 77: Resurrection, c. 1475-77, tempera (and oil?) on panel transferred to canvas, 148 x 128 cm, Berlin, Gemäldegalerie, n. 1177A

p. 87: Assumption of the Virgin, c. 1505-10, oil on panel, 350 x 190 cm, Murano, San Pietro Martire

p. 88 : Christ Blessing, c. 1500, tempera and oil on panel, 59 x 47 cm, Fort Worth, Kimbell Art Museum, n. AP 1967.07

p. 91: Virgin and Child (Morelli Madonna), c. 1485, tempera on panel, 83 x 66 cm, Bergamo, Accademia Carrara

p. 92: Virgin and Child with Sts Peter and Mark (?) and the donor, 1505, oil on panel, 92 x 80 cm, Birmingham, City Art Gallery

p. 96: Portrait of a Man (Pietro Bembo?), c. 1505, oil on panel, 42.6 x 34.1 cm, Windsor, Royal Collection, n. 277

pp. 99 and 112-13: The Feast of the Gods, c. 1514/1529, oil on canvas, Washington, National Gallery of Art, Widener Collection, n. 597

p. 116: Vittore Gambello, portrait medal of Giovanni Bellini, c. 1500, 60 mm wide, New York, Metropolitan Museum of Art

Cover: Vittore Belliniano, Portrait of man in profile from the left, wearing a calotte (Giovanni Bellini), 1505, pen and brown ink, black chalk, brown wash, 10.9 x 8.8 cm. Chantilly, Musée Condé, Inv. DE121

Photographs on p. 1: courtesy Musei Civici Pesaro (www.pesaromuseo.it); on pp. 2, 10-11, 15, 18, 30, 32-33, 42, 52-53, 73, 84-85, 87 102, 105 and 106, courtesy Cameraphoto, Venice; on pp. 4 and 116 courtesy Metropolitan Museum of Art; on pp. 6, 20-21, 61, 99 and 112-113 courtesy National Gallery of Art, Washington DC; on p. 8, 22-23, 28, 68, 88, 109 and 110 Google Art Project; on pp. 17 and 64-65 Bridgeman Art Library; on p. 25 courtesy Didier Descouens; on pp. 36, 91 courtesy Wikipedia; on p. 47 courtesy British Museum; on p. 55 courtesy Wikimedia Commons; on p. 77 courtesy bpk/Gemäldegalerie, SMB/Jörg P. Anders; on p. 92 Photo © Birmingham Museums Trust; on p. 96 courtesy of Royal Collection Trust/© Her Majesty Queen Elizabeth II 2017; on cover Photo by René-Gabriel Ojeda/© RMN-Grand Palais/Art Resource NY

© 2018 Pallas Athene
Introduction by Davide Gasparotto © 2018 J. Paul Getty Trust

Published in the United States of America by the J. Paul Getty Museum, Los Angeles
Getty Publications
1200 Getty Center Drive, Suite 500
Los Angeles, California 90049-1682
www.getty.edu/publications

Distributed in the United States and Canada by the University of Chicago Press

Printed in China

ISBN 978-1-60606-564-8
Library of Congress Control Number: 2017946357

Published simultaneously in the United Kingdom by Pallas Athene
Studio 11A, Archway Studios, 25–27 Bickerton Road, London N19 5JT
Series editor: Alexander Fyjis-Walker Editorial assistants: Anaïs Métais and Patrick Davies

The life by Vasari was translated by Gaston du C. de Vere and first published in 1912.

The life by Ridolfi, the extract from Boschini's *The Map of Pictorial Navigation*, and the Isabella d'Este correspondence were all translated for this edition by Frank Dabell.

With very many thanks to Christopher Ligota for the translations of Latin inscriptions on pp. 79–83; and to Aileen Feng, University of Arizona, for kind permission to use her translation of Pietro Bembo's sonnet "O imagine mia" on pp. 95–97, which was originally published in *Writing Beloveds: Humanist Petrarchism and the Politics of Gender* (University of Toronto Press, 2017). The translation of the epitaph on p. 74 is by Charles Eastlake.

Front cover: Vittore Belliniano (*c.* 1485–1529), *Portrait of a man in profile, from the left, wearing a calotte (Giovanni Bellini)*, 1505. Pen and brown ink, black chalk, brown wash, 10.9 x 8.8 cm (4⁵⁄₁₆ x 3⁷⁄₁₆). Musée Condé, Chantilly, France, Inv. DE121. Photo: René-Gabriel Ojeda / © RMN-Grand Palais / Art Resource, NY